Modigliani

Modigliani

Douglas Hall

Phaidon · Oxford

Phaidon Press Limited, Littlegate House, St Ebbe's Street, Oxford OX1 1SQ
First published 1979
This edition, revised and enlarged, first published 1984
© 1984 Phaidon Press Limited

British Library Cataloguing in Publication Data

Hall, Douglas *1926–*
 Modigliani
 1. Modigliani, Amedeo 2. Painters—Italy—
Biography
 759.5 ND623.M67

 ISBN 0-7148-2270-1
 ISBN 0-7148-2271-X (pbk)

Typeset, printed and bound in Singapore, under co-ordination by
GnP Consultants Private Limited.

The publishers wish to thank Signora Angela Ceroni, and all those museum authorities and private owners who have kindly allowed works in their possession to be reproduced. They have endeavoured to credit all known persons holding copyright or reproduction rights for the illustrations in this book.
Acknowledgement is made for Plate 8 to Marlborough Fine Art, London; for Plate 48, Copyright Sotheby Parke-Bernet Inc., New York; for Figs. 21 and 39, Bulloz, Paris; for Plates 16, 19 and 24, and Fig. 19, Giraudon, Paris; and for Figs. 25 and 26, Clichés des Musées Nationaux, Paris.

Modigliani

Modigliani is nowadays a popular artist. The subject-matter of his painting is limited and easily understood, consisting almost entirely of portraits and nudes. His style is easily recognizable. For those who wish to go a little below the surface and find in him a true pioneer of modern art, there are his austerely beautiful but primitivistic sculptures, while his drawings satisfy the eye with a virtuosity that modern art often withholds. His bohemian life in Paris gave rise to a legend, true in basic particulars, which makes him, almost as much as Van Gogh, a type for the artist at odds with society. His life was short, as an artist's life must be for his story to be seen in simplicity and bright colours. Born in Italy in 1884, he came to Paris at the age of 21, and died, of tuberculosis aggravated by alcoholism and drug-addiction, in January 1920, aged 35. Neglected as long as he lived, it is reported that at his funeral dealers were negotiating a new price-level for his paintings.

Modigliani can seem a very different figure, according to which kind of literature one reads. To the critical writers of the more aesthetic kind he is ethereal, elevated, a profound psychologist. To the writers of anecdotal biography he is interesting because of his excesses with women, alcohol and drugs, and his scandalous behaviour generally during his last few years of life. It is doubtful whether a satisfactory historical account of Modigliani can now be written, since no new sources are likely to be tapped. Few people are still alive who knew him personally. The dealings of the Paris art world in Modigliani's time there (1906–20), a time when many reputations and fortunes were being made, have always been impenetrable to enquiry. The situation is not very different for other artists of the School of Paris who were not successful enough to attract chroniclers and cataloguers at an early stage, as Picasso did; or who belonged to the underworld of art, like Utrillo, Soutine or Pascin, and Modigliani himself.

This underworld of art in Paris is a phenomenon which has not received the scrutiny which it deserves from the psychological and sociological points of view. For the present it can only be described in the baldest terms. This was the phenomenon from which came a group of artists, including Modigliani, who were dubbed *les peintres maudits*. 'Accursed painters' rather than 'damned painters' would be the better translation of the term; it implies that they were in some way fated, not merely a nuisance. No doubt they were considered to be both. The elements that made up the situation of this group were alienation, poverty,

weakness – and brilliance. Most of them were foreign, and for all that Paris beckoned aspiring foreign artists, it did not welcome them. If they were not only foreign but disadvantaged by being for example Jews, or of the peasant class, or from outlying parts of Europe, their isolation from Paris was assured. Their poverty goes without saying, and what might be called the poverty trap, whose other jaw is alienation, duly closed on them. No doubt hundreds of artists coming to Paris were caught by this trap and left no record of success or failure. Conversely some of the most famous names in modern art came to Paris under such disabilities — typically they were poor Russian or Baltic Jews or East Europeans. Chagall, Lipchitz, Zadkine, Brancusi are examples. They overcame alienation, lived through poverty to success and acceptance, and did not become *peintres maudits* (or *sculpteurs maudits*). For that the third element was necessary — call it weakness, or an inner disposition to succumb.

The last element to make up the *peintres maudits*, brilliance, was necessary to their historical survival. For although there were good and less good artists among them, none received attention without achievement. What was the connection between their achievement and the disorderly lives they led? That is the interesting question. Their phenomenon was not quite a new one. The exceptional nature of artists has often been stressed, and this has included eccentricity, sexual deviance, political dissent, social unacceptability, madness feigned or real. The peculiarities of artists came into prominence at romantic periods. Yet for romantics, realists and abstractionists alike, poverty and alienation came from being ahead of the taste of those who might support them. And from this came also the possibility of speculation in their works. The artist as deviant might become the artist as celebrity. By the time Modigliani came on the scene, speculation in contemporary art was well established, owing to the precedent set by the Impressionists. The new element in the twentieth century which increased the opportunities for speculation was the recognition and appreciation of neurotic art. As the appetite for originality and intensity of expression grew, it was increasingly recognized that these qualities could not come from skill or experience alone, or from the lives of normal members of society.

How did Modigliani, who was not uncultured, primitive, boorish or really poor, and who spoke perfect French, become a member of this ill-starred group? Why did he find his closest friends in Soutine, the slovenly and dirt-poor Baltic peasant who cared for nothing but the act of painting, or the simpleton Maurice Utrillo? These questions can never wholly be answered, as Modigliani's biography can never be wholly complete. We can only find

tentative answers in his background and heredity as they reacted with the Parisian situation. The new climate of speculation in artistic reputations already noted, carried on with the characteristic entrepreneurial ruthlessness of the time, was one factor in this situation. Within a short time of Modigliani's arrival, some of his own generation were already benefiting from speculative attention. They were the strong characters, pre-eminently Picasso. For the weak-minded, speculation was likely to take the form of sheer exploitation or calculating neglect. It seems to have been the latter that wounded Modigliani particularly. Although weak in a sense, he would have been intolerant of obvious exploitation.

The other element in the Parisian situation that was necessary to Modigliani's tragedy is more strictly a matter of cultural history. The cultural atmosphere of Paris, as elsewhere in Europe at the turn of the century, was determined by the literary and artistic movement of Symbolism, which encouraged an intense subjectivism and intolerance of norms, extending, at least on paper, to conduct and lifestyle. The gap between art and life had become an increasingly dangerous territory during the nineteenth and twentieth centuries, and by his conditioning and his self-destructive character-traits Modigliani was predisposed to fall into it. He was the victim of a confusion between the two and of an immature self-deception about the role of artists. Fortunately Modigliani's youthful background is quite well documented, so that one may understand up to a point how he came at last to attract the term *maudit* — that ironic pun on his shortened name.

Amedeo Modigliani was born at Leghorn on 12 July 1884. He was the youngest of four children of Flaminio Modigliani and his wife Eugenia Garsin. The family was impoverished at the time of Amedeo's birth and had never, contrary to legend, been more than moderately prosperous. Both his parents were Jews, but of different traditions. Eugenia Garsin came of a line of Spanish Jews settled for four generations in Marseilles, austere but liberal in their attitude to religion, philosophy and culture. Flaminio Modigliani came of strict Italian Jews from Rome, but seems to have been a weak man, who counted for little after his business failures in the year of Amedeo's birth. His frequent absences were perhaps little noticed, as the household and family was an extended one and included, besides the four children, Eugenia's two sisters, and at times her father and her maternal grandmother. Eugenia was the real head of the household and often the breadwinner.

The chances were that the youngest child in an extended Italian family would be spoiled, but there were also malign indications in Amedeo's environment and heredity. His grandfather, with whom

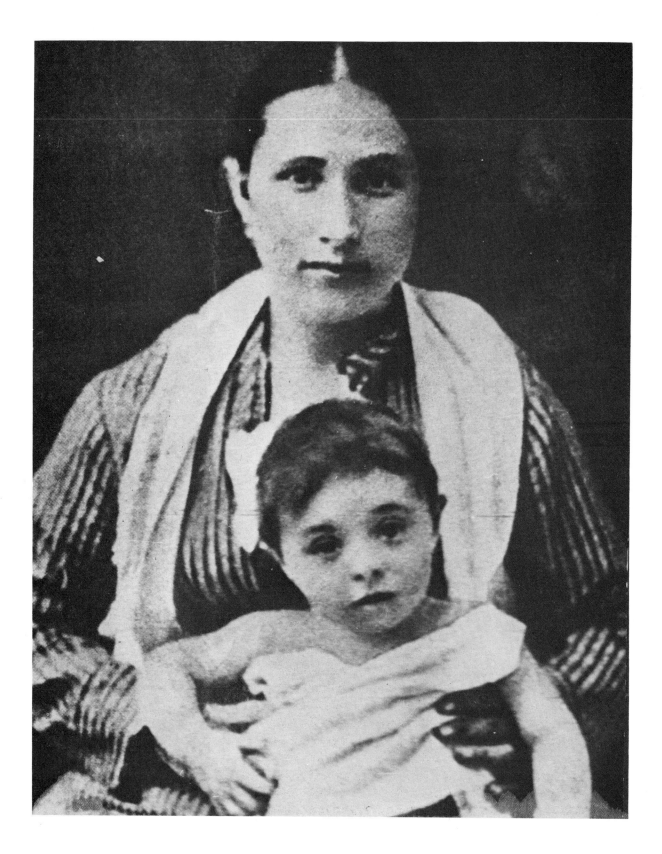

he spent much time, an aunt and a sister all suffered from feelings of persecution. Amedeo's grandmother Regina died of tuberculosis. His aunt Gabriella committed suicide in 1915. His uncle, after whom he was named and who paid for his travels, died in about 1905, a mercurial man doomed to unhappiness. Eugenia was the kingpin of an intensely feeling and self-destructive family. When Amedeo himself showed the first signs of physical weakness, his mother brought all the force of her overwhelming maternal attention and affection to bear on the young boy. He remained a mother's darling into his teens. We first hear of Amedeo (Dedo to his family) in his mother's diary as 'a little spoiled, a little capricious, but *joli comme un coeur*' at the age of two. His good looks were to remain a byword for the rest of his life. In 1895 he frightened his mother with an attack of pleurisy. She writes of his unformed character, his temper and his intelligence. In 1897 Eugenia wrote that Amedeo 'already sees himself as a painter', and was about to start drawing lessons. It was a way out, she thought, from the apathy and sadness that seemed to beset the whole family. Unfortunately more trouble was to come. In the summer of 1898 Amedeo fell ill with typhoid fever.

The attack of typhoid in 1898 was a turning point in Amedeo's life. Narrowly recovered from it, he was allowed to give up school and join the studio of Guglielmo Micheli, a Leghorn painter who was a late representative of the *macchiaioli* school of Italian *plein-air* painting. But illness soon struck him again; in 1900, probably in September, he again contracted pleurisy and this time was left with the tuberculosis which, even more than drink or drugs, contributed to his premature death. But for the time being he recovered, and we feel that it was Eugenia's intense maternal solicitude that pulled him through. When he was better she took him on a tour in the south of Italy. They went to Naples, Capri, Rome, Amalfi, then north again to Florence and Venice. Once broken out of the limits of Leghorn, Amedeo soon left home again by himself. On 7 May 1902 he enrolled at the Academy of Fine Art in Florence, in the class of the respected Leghorn *macchiaiolo* Giovanni Fattori, but on 19 May 1903 he was to enrol again for the same course, only this time at Venice.

Modigliani seems generally to have pleased his teachers as a young man, but nothing is known of his performance at the Academies of Florence and Venice. The chronology of his life between his first break from home in 1902 and the bigger break to Paris in 1906 is obscure. Probably he attended the classes seldom. At this stage, when his work could be expected to come to the aid of the story, we find that almost nothing has survived. Whether he himself destroyed it is not certain. It is quite probable that he actually

Fig. 2 (opposite)
Modigliani at 13 Months
PHOTOGRAPH. 1885. LIVORNO, MUSEO FATTORI

9

produced very little then. The very intensity of his professed passion to work perhaps made it difficult to get down to it. But there was another, perfectly genuine reason for his painting little. Modigliani had decided to be a sculptor. An undated postcard from Pietrasanta, the marble-working town near Carrara, asks his friend Romiti to arrange for enlarged photographs of a sculpture. This card was dated 1902 by Romiti. So Modigliani, who had scarcely broken away from his mother's apron-strings and was supposed to be enrolled in the life school at Florence, had taken lodgings at Pietrasanta and produced a carving of which he was proud. This sculpture cannot be identified, and the photograph has not been found. After this — to the confusion of his family, who had scarcely got used to his vocation as painter — he proclaimed himself a sculptor. If Modigliani produced many more paintings than sculptures, it was because he was often too ill to carve stone, which raised dust, or he had no room or materials. Also, many of the carvings he managed to produce have been lost or destroyed.

Modigliani's early love affair with sculpture indicates his independence from his Italian contemporaries and teachers. It has been said that Modigliani's true teachers were the old masters he saw in Rome, Florence and Venice. He did not speak of the sculptures he saw there, but his own sculpture leads us to suppose that he admired medieval rather than Renaissance sculpture. The influence of primitive sculpture that he encountered later in Paris was grafted on to this. But Modigliani's fellow-students in Italy must have been an important influence on him. One of them, Oscar Ghiglia, cannot be omitted from even a short account of Modigliani's life. Ghiglia was eight years older, and Modigliani's sister, admittedly a prejudiced source, indicated that Ghiglia was a bad influence on him, and the first to introduce him to drugs. (According to an even more precocious youth who knew Modigliani in Venice in 1903, he was at that time taking hashish.) However, Ghiglia's importance to our understanding of Modigliani is in the letters Amedeo addressed to him from his travels in 1901, which show that the influence was not all one way.

Modigliani's five letters to Ghiglia are almost the only statements of his that have survived, and they give a good picture of the state of his mind. Art, life and work jostle each other in these febrile, boyish letters. He confesses to 'a tumult of beautiful images and antique voluptuousness in my spirit' (with a sidelong hint of erotic adventures); and feels 'the prey of strong forces that are born and die in me'. He remarks self-consciously to Ghiglia, ignoring the age difference between them, that they had parted 'at the most critical moment of our intellectual and artistic development'; but

10

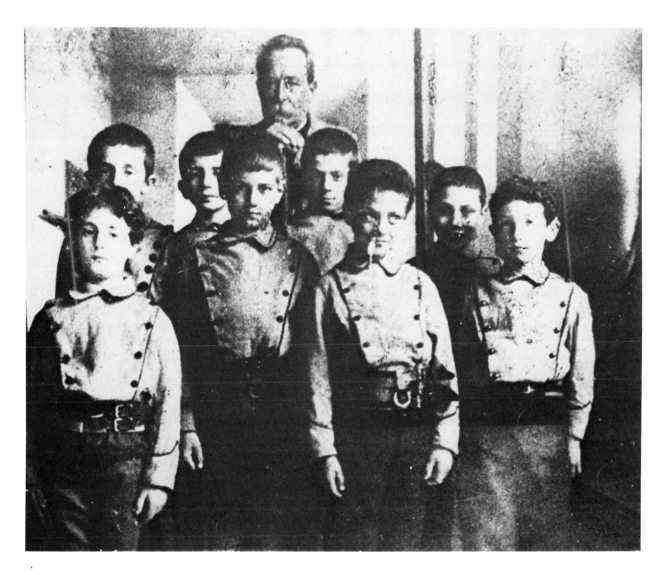

when Ghiglia eventually replies in a state of depression, Modigliani tells him 'your real duty is to save your dream'. There are also sentiments which show a solid perception of the artist's job. He promises to dedicate himself faithfully 'to the organization and development of every impression'. He understands the need to reveal and rearrange what he calls the 'metaphysical architecture' of his ideas and experiences and to await their natural gestation. It is in the last letter to Ghiglia, written in desperate response to his friend's trouble, that he clearly reveals the ideas that were to determine his own future. 'People like us . . . have different rights from other people because we have different needs which put us – it has to be said and you must believe it – above their moral standards. Hold sacred . . . everything that will stimulate and excite

Fig. 3
Modigliani (front row, far left)
in an Elementary School at
Livorno, *c.* 1895
PHOTOGRAPH. LIVORNO, MUSEO FATTORI

your intellect.' And with supreme irony: 'the man who cannot . . . as it were create new personalities within him to fight always against the worn-out and rotten, is not a man.'

This is pretty pure Nietzsche. But it was not only a matter of Nietzsche. Modigliani had received a good literary education at school and at home. He must certainly have been aware of the literary cult of depravity, which was supposed to produce the finest flowers of symbolist poetry. One of its extremest manifestations, *Les Chants de Maldoror* by the self-styled Comte de Lautréamont, was a well-thumbed possession of Modigliani's. This nightmarish, sadistic and irrational book was to become a source for the Surrealists after Modigliani's death. Yet Modigliani's work is not at all troubled by premonitions of surrealism, or much affected by memories of symbolism. He took the drug of *Les Chants de Maldoror* as he took other drugs, directly.

Thanks to the impression he made on the memories of his family and friends, his letters to Ghiglia, and a few other sources, it is possible to form a reasonably complete picture of Modigliani as he was on arrival in Paris in 1906. There was still about him much of the pampered, self-willed child of a weak father and a strong mother. His illness had made him the centre of morbid attention, and had probably ended by impressing on his mind an idea of fatality. His family history was full of physical and mental disability and he already carried this liability in his own body and mind. His appearance was striking, his manners were elegant and rather lordly, though tempered by a recurring shyness – at least when he was sober. He was an instant success with most women. His ideas were large and his talk was even larger. He was given to fantasy. Some of the myths that circulated about him were probably propagated by Modigliani himself; certainly those that concerned his family came from him, namely that his mother was descended from the philosopher Spinoza and his father from rich bankers who had lent money to Popes. His pride was great, especially with regard to his race. He would introduce himself: 'Je suis Modigliani, juif', and was quick to resent any hint of anti-semitism. He had lived with highly intelligent and over-sensitive people whose minds were open to the bewildering mixture of philosophical, literary and political ideas of the late nineteenth century, in which Nietzschian irrationalism and glorification of the superior individual mingled with literary symbolism and political socialism.

So much for his traits. When we come to his artistic formation at that point, the picture is much more vague. But certainly, Modigliani's world so far had offered him no visual counterpart to the ideas just described, and he was never to find one. They issued in

Fig. 4 (opposite)
Self-Portrait

OIL ON CANVAS, 100 × 65 CM. 1919. PRIVATE
COLLECTION

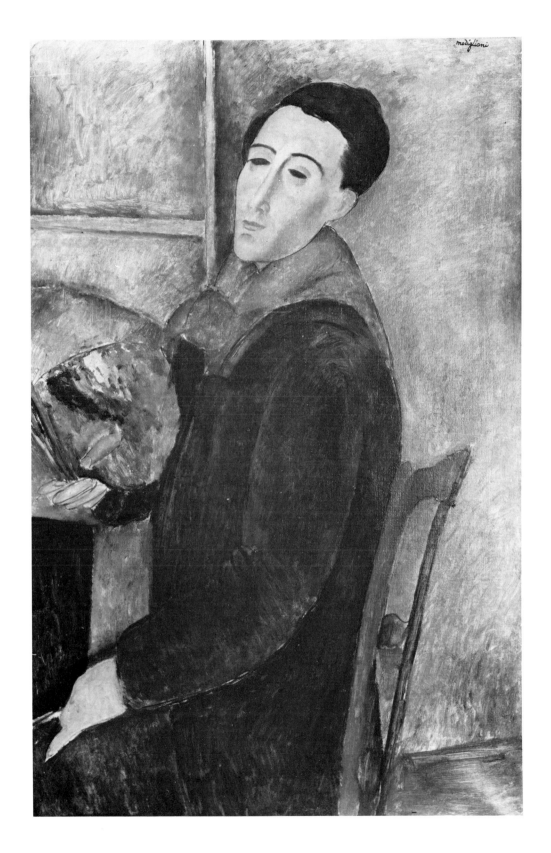

13

his talk and behaviour, leaving his work stamped with his personality, unavoidably so, but not with his ideas. What determined the form of his work was his own conception of a style, grafted to what he had absorbed of Italian art and reared in the forcing-house of Paris.

In the heady atmosphere of Paris, Modigliani never submitted to the influence of anyone except, in the most general sense, Toulouse-Lautrec and Cézanne; never of his contemporaries. That is the positive side of his intense pride. But his pride was also the cause of the decline of the beautiful young Italian into a drunken, quarrelsome braggart and failure. The plain fact is that when success did not come, Modigliani was too proud to change his course, to look for another way of maintaining himself, or to husband his small resources. Not knowing which way to turn, and committed by his Latin nature to life as a series of confrontations with others, he was forced to adhere ever more stridently to the poses he had struck, which became ever more hollow and debilitating. So fantasy turned to bombast, larking to destructiveness, and pride to morbid touchiness. The manifestations of this process have provided most of the material for his biographers. This would be justifiable if the incidents described threw any light on his work. Mostly they do not. It is no surprise that the biographical and critical studies of Modigliani are so far apart, as it is so difficult to bring his life and his work into focus together.

Modigliani arrived in Paris in January 1906. For some weeks he lived in a comfortable hotel, but soon gravitated towards the two artists' quarters of Montparnasse and Montmartre. Aware that he had still a lot of learning to do, he enrolled at the Académie Colorossi. The first evidence of any work done refers to 'the winter of 1906', when a compatriot saw some heads of women in a little gallery run by an Englishwoman on the left bank. From their description it is evident that they were symbolist paintings slightly in the manner of Carrière. Two if not three of these were in the Alexandre collection. It was in the autumn of 1907 that Modigliani met his first, almost his only private patron, Dr Paul Alexandre. Thanks to him, some twenty-five early paintings and numerous drawings have been preserved, though never fully published.

Paul Alexandre was not much older than Modigliani himself. He lived with his father and his brother Jean, with the latter of whom he had set up a free house for artists at 7 rue du Delta. Alexandre seems to have favoured Modigliani most among the artists who came to the rue du Delta, although he was probably the most troublesome. The story is that he was eventually barred from the colony for the worst of crimes in such a society – destroying the

work of another artist. That did not prevent Paul Alexandre, in old age, from remembering him as 'a very well brought-up young man'. In a sense he was. He was also a fascinating medical case, both mentally and physically – a walking casebook of the parapsychology of creation. Alas, if Alexandre ever regarded him in that light and made notes, they have never been published. He himself was 'of the movement', believed in hashish taken in moderation, and shared in the passionate vogue for primitive art. While he knew Modigliani, the latter was still high-spirited rather than violent, and still able to adapt himself to bourgeois deportment, as he had to, for he painted the dignified father as well as both sons. Later on, when the violent oscillations of Modigliani's behaviour were destroying him, Dr Alexandre had gone to the war, then married and lost touch with his bohemian protégés.

It is possible that the 'bloodless heads of women' seen in the Englishwoman's gallery were done in Italy, though they resemble the work of a French symbolist. There can be no such doubt with the group of paintings centred round the Alexandre portraits (Plates 1, 2 and 3). They are completely of Paris, and show above all the influence of Cézanne mingled with that of Toulouse-Lautrec. From Cézanne come the unifying pattern of brush-strokes, the diagonal *passage* across the canvas; from Lautrec the biting delineation of character through the drawing of features. The influence of Picasso, who himself had drawn heavily on Lautrec, is more problematical. There is evidence that Modigliani was a little obsessed by Picasso at this time and knew that his own work resembled the Spaniard's but was still inferior to it. Adapting to the new light of Paris had also given him new ideas on colour, owing something to the *fauves*.

The truth is that Modigliani's work at this time was highly experimental. His taste was forming – he still admired Sargent and even Boldini, slickest of society portraitists, even while he was jealous of Picasso. Consider the early works reproduced in this book. *The Horsewoman* (Plate 3) is a would-be society portrait whose mordancy comes from Lautrec. Other works, which must be near in date, ignore the study of personality in favour of Cézannian study of volumes. Earlier than these is a group of Lautrec-like, somewhat expressionist works all showing the same model, a severe-looking, statuesque Jewess (Plate 1). Perhaps the finest of the paintings datable to the early Paris period is the magnificent portrait of Pedro, 'the painter', a work of great solidity and penetration of character (Plate 2).

What of his sculpture at this period? It is impossible to say. But scattered among Modigliani's paintings are a handful in which painting and sculpture draw close together. One of a young girl

(Ceroni I, 9; see Bibliography) is as early as 1908. The body is remarkable, but painterly – it is Matisse almost before Matisse. But the stupid, pursed-up little face is rounded and polished like a marble. Moreover, here for the first time in painting is Modigliani's typical round, columnar neck. This neck was surely first evolved in sculpture, but when? The chronology of the sculptures is impossible to determine. There are many anecdotes about this sculpture, for example that he took a barrowload of heads to Dr Alexandre in 1913 (this in Alexandre's own account to Ceroni) and that he stole sleepers from the Métro, though there is only one wooden carving in existence, not universally accepted as Modigliani's work. The most convincing and tragic anecdote has it that on his last recuperative visit to Italy, in 1912, he obtained stone and shut himself up to sculpt, but that his friends did not appreciate the carvings and advised him when he left to throw them into the canal. It has been inferred that he did this; at any rate no surviving sculpture can be securely dated to this time.

However, a photograph (Fig. 5) shows Modigliani standing by an unfinished stone head which is similar to our Plate 4. This photograph was most likely taken on his return to Paris, as his appearance fits with the one his Italian friends remembered from his visit. Possibly the sculpture was one he actually did bring back from Italy and finished in Paris. It rests on a bolted construction that could be a travelling crate. But before this he had had four elongated heads photographed in the studio of a friend in 1911. In the autumn of 1912 he successfully submitted no less than seven heads to the Salon d'Automne, where they were catalogued as *Têtes ensemble décoratif*. In Ceroni's opinion, *all* Modigliani's sculpture was executed in 1911–12. This seems impossible, although the evidence suggests many of them were done then. Plate 4 seems to belong to a different order of creative endeavour from the superb head in the Tate Gallery (Plate 14). This head is among the most perfectly finished, and is also the one in which the native Italian and the primitivist influences are most perfectly integrated. In this type of sculpture the features are fully part of the total form, while in many others, Plate 4 among them, they are on the surface only. It is tempting to think the Tate head later, but it was surely one of the ensemble exhibited in 1912.

Modigliani's sculpture deserves to be considered separately from the farrago of anecdote that surrounds his painting life. In it he was at his most serious, and his work has connections with the pioneers of modern sculpture even outside his immediate acquaintance, an acquaintance which, however, included Brancusi, Epstein, Archipenko, Lipchitz and Zadkine. Modigliani's 'decorative ensemble' is a reminder of the ambition of sculptors in the

Fig. 5
Modigliani at the Cité
Falguière, with a Sculpture,
c. 1912

PHOTOGRAPH. PRIVATE COLLECTION

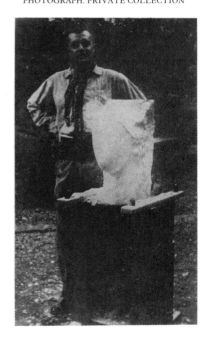

16

Fig. 6
Modigliani, *c.* 1915
PHOTOGRAPH. PRIVATE COLLECTION

early modern epoch, when large schemes of sculpture on buildings were still quite usual. He dreamed of a 'temple' sustained by caryatids, exactly the same dream that seduced Mestrovic at the same time and which, thanks to Serbian nationalism, he was partly successful in realizing. Epstein, Brancusi and others also had their grand concepts which they were able to execute in some form or other. Here, as always, Modigliani was the unlucky one.

Modigliani probably did little more in sculpture after 1913. At all times he drew. The most well-known Modigliani of the legend is the handsome, tragic young man handing out drawings in cafés, for a few francs, for a drink, or for nothing at all. Modigliani drew in cafés from his first arrival in Paris, but probably not as a lifestyle until after 1913 or 1914. This may account for the impression of some witnesses that he had just started to draw. The few paintings datable to those two years are still very tentative, which is consistent with the belief that he had been concentrating on sculpture. As if exploring the possibilities of a new medium, he produced in 1914 a remarkable pair of portraits in his most 'painterly' manner (Plates 16 and 17), with very little use of line and with dots

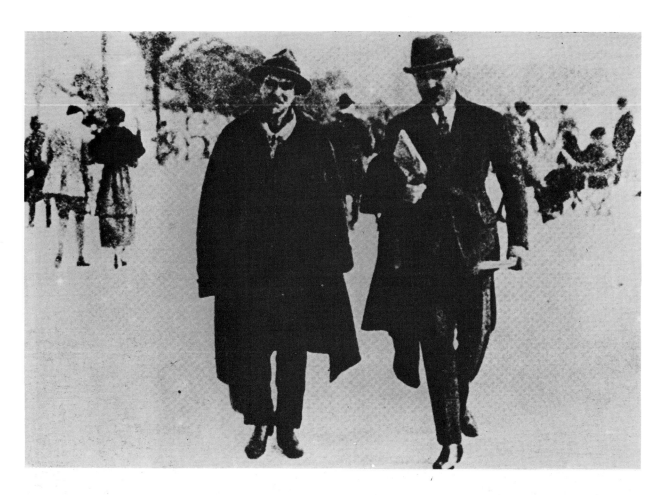

Fig. 7
Modigliani and Paul Guillaume
at Nice, 1918/19
PHOTOGRAPH. LIVORNO, MUSEO FATTORI

of colour applied in a *fauve*, almost *tachiste* way, leaving much of the ground uncovered.

1914 was something of a milestone in Modigliani's tragedy. Discouraged with sculpture and often ill, he was launched on his brief, unhappy trajectory as painter. The war removed from Paris his friend Alexandre, as it removed the capable French members of the artists' circles, leaving the cafés to the foreigner, the unfit and the misfit. The chances of genuine sales were reduced, and the climate became even more favourable to the speculators. It was during the war that Modigliani found his only two dealers: Paul Guillaume (Plate 23) and Leopold Zborowski (Plate 35). Modigliani painted Guillaume several times, and wrote on one of the portraits the words *Novo Pilota*, the new man who would pilot him to fortune. Alas, Modigliani was never one to be piloted anywhere. Zborowski he painted often, sometimes as friend, sometimes as dealer and man of affairs.

By 1914, a form of watered-down cubism had become the dominant mode in advanced studios in Paris. Modigliani was

18

jealous of this, but no doubt Guillaume and Zborowski would have been glad if he had painted them cubist pictures. In fact, 1915 and 1916 are often described as Modigliani's cubist period. *Celso Lagar* (Plate 20) and *The Bride and Groom* (Plate 21), one of his rare double portraits, illustrate how much or how little this is justified. Modigliani uses compositional diagonals and structural lines unconnected with outlines. He uses linear shorthand for features, and adopts a sub-cubist device of representing the nose in profile in a full face (Plate 21). These features may seem like a concession to cubism in a painter as individual as Modigliani, but in *The Bride and Groom* they result not in the rich and heavy weave of cubist painting but in a deft, witty comment almost in the manner of Klee. And the paintings that are reproduced from Plate 18 to Plate 24 show what a great range of emotional expression Modigliani could encompass in his so-called cubist works. These works include some of the least sculptural he did, as if, on the rebound from

Fig. 8
Soutine and Zborowski
PHOTOGRAPH. PRIVATE COLLECTION

19

his intense involvement with sculpture, he was pushing hard into a new territory.

How much was he aided, in exploring this new territory of painting, by drug-induced euphoria? The legend has Modigliani under drugs suddenly discovering the 'right road' – i.e. drawing his first woman with a swan neck. This is palpable nonsense. The long neck was a sculptural device which appears in his painting at an early stage. It was by no means universal in the cubist period nor even became so later. It was not reserved for women; two of the most masculine sitters Modigliani ever had, Henri Laurens the sculptor (1915; Fig. 19) and the stunt actor Gaston Modot (1918), have the longest necks. But admittedly Modigliani endowed the important women in his life with this attribute, and none has a longer neck than Beatrice Hastings (Plate 18).

Modigliani met Beatrice Hastings in 1914, just before the war. To his circle, she was 'the English poetess'; in reality she was a South African journalist, though she wrote poems. Modigliani and Hastings lived together in an extremely stormy liaison from 1914 to 1915 or 1916. His portraits of her show oddly little evidence of this. Occasionally, her *chic* and sophistication are hinted at, but never her termagant nature. Most often she is shown round-faced, small-featured, blank of expression (Plate 18). The wistful sadness of Modigliani's later portraits had not yet developed at this time. Perhaps such an abrasive woman as Beatrice could hardly be represented as wistful. Physically she suffered at his hands; probably she redressed the balance in other ways. Modigliani's ritualistic, adversarial extremism demanded in others the right sort of response – it required the submissive woman, the complaisant friend, as a sort of counterpoint. Beatrice would not play, and by not doing so she perhaps gave his behaviour a dimension of real unpleasantness it did not have before.

Throughout his painting career the eyes in Modigliani's portraits are remarkable, and often he represents them as blank. This practice was most common in 1915 and 1916, and sometimes they are not only blank but criss-crossed with hatched lines (Plate 23). Modigliani told a young friend that these little diamond panes were 'to filter the light'. At the other extreme are eyes larger, more lustrous and penetrating than is perfectly comfortable (Plate 24). Yet whether or not pupils and irises are shown, the eye is always expressive. This is because of Modigliani's miraculous gift for composing the elements of the face. Whatever distortions are employed, whether the face is elongated, compressed, inflated or mercilessly pulled into a cruel simulacrum of some physical oddity, the features fall into place like the inside parts of a musical harmony. The unusually formal and complex portrait of Jean

Fig. 9
Modigliani, Max Jacob, André
Salmon and Ortiz de Zarate,
Paris, c. 1916

PHOTOGRAPH. PRIVATE COLLECTION

Cocteau of 1916 (Plate 22) marks a transition between the 'cubist'
and the 'classic' periods in the type of distortion employed. The
angularity of the drawing, the nose thrust ruthlessly into a profile
position, the prominent cheekbones and pointed chin, favour a
cubist interpretation, and are exactly suited to the razor-sharp
intelligence and singularity of the sitter, while the formal clothes,
square shoulders and high chair-back suggest the oracle and
arbiter of taste, and belong more naturally to the 'classic' portraits.

In 1915 and 1916, with Beatrice Hastings and Paul Guillaume as
his worldly mentors, Modigliani was perhaps near to 'success'. But
as they were also years of increasing depression and aberration, not
surprisingly success eluded him. Some time in 1916 the more
bohemian and tolerant Zborowski took over from Guillaume the
self-appointed task of promoting Modigliani's work. From then on
Zborowski and his seemingly hard-boiled wife (Plate 31) were to
guide his life and to be his only source of funds – his small
allowance from home having ceased with the war. After his final
break with Beatrice, the legend has him involved in many affairs.

21

His liaison with Simone Thiroux, who bore him a child, seems to have been ended brutally by him. By contrast, his life with Jeanne Hébuterne, student and painter, from Easter 1917 to his death, was the nearest he knew to marriage. These were both quiet, complaisant women who adored him and were incapable of reforming him, or trying to. His relationship with the mysterious Lunia Czechowska, unusual in that it may not have been consummated, was then the only one on a level of intellectual equality. In her memoirs she claims that she temporarily reformed him. In 1918 Modigliani's state was so bad that the Zborowskis somehow arranged for them all to go to Nice. Jeanne Hébuterne had her baby there in November. In May 1919 Modigliani was better and returned alone to Paris, where, according to Lunia Czechowska, he enjoyed several weeks of calm life under her influence without drinking. Unfortunately, after Jeanne's return with the child, the vicious spiral resumed.

Modigliani's sexual life is of course a staple with his biographers, and may seem to find its visible expression in the catalogues with his series of magnificent nudes (Plates 26, 27, 36–39). It is in fact impossible to correlate Modigliani's legendary sexual history with the surviving nudes. There is no nude painting of Beatrice and no nude or portrait identified as Simone. Probably most of Modigliani's nudes are of professional models, whether or not they were paid. It is assumed or asserted by certain writers that Modigliani had sexual relations with all his models. This shabby assertion seems to belittle the professionalism which he managed to preserve through all his vagaries. It assumes that he could not project his undoubted sensuality by generalization, without having immediate satisfaction from these particular women. The look on their faces, languorous, expectant or knowing, may seem to support the assertion. However, with some exceptions the nudes of Modigliani cannot be regarded just as portraits of women without their clothes. He was not aiming to depict sexual phenomena like Pascin. His ambitions were higher. Pascin and Foujita, his bohemian contemporaries, can never be seen, as Modigliani can, as inheriting the grand tradition of the nude from Giorgione and Titian through Rubens to Boucher, Goya, Manet and Renoir.

It is his capacity to reveal general truth within the analysis of detail that makes Modigliani a major artist, and establishes his succession to the grand Italian manner. An interesting comparison is with Degas, who was able to extract a classical sense of permanence from the flux of contemporary life. Compared with Degas, Modigliani's life was disorderly, yet he began with an instinctive sense of order both in his narrow choice of subject and in his capacity to design a painting. The paradox of Modigliani is

that his classicism was finally reached only during his last three years of declining health and sanity.

Not much more need be told here about Modigliani's life. His recovery in the summer of 1919 did not last, and Lunia failed to persuade him to accompany her again to the south. He played with the idea of returning to Italy, saying reportedly 'only Maman knows what is good for me'. But he did not go, any more than he heeded the pleas of Zborowski and others to have treatment. The impression is inescapable that Modigliani wanted to die. The accounts of his roaming the streets of Paris, drunk or soaked through, in his last weeks, vie with each other in their tragic pathos. On 22 January 1920 he was taken to hospital in a coma and died two days later. The following day Jeanne Hébuterne threw herself from the window of her parents' apartment and died. She was then about seven months pregnant.

It is against this sad background that the last two styles of Modigliani must be seen. Compared with the portraits of Cocteau or Guillaume, a new tranquillity can be seen in the *Portrait of a Girl* (Plate 34) or the *Portrait of a Girl (Victoria)* (Plate 30). These images are enclosed in a firm but flowing outline, within which the features and details of the face, hair and clothing are developed in a more integral way, in a way less concerned with surface drawing than with coherence of detail within the general form. The placing of the figures within the canvas and their own postures tend to be more relaxed at this period than before. The influence of Cézanne re-asserted itself in 1918; perhaps it was part of the effect of Modigliani's year in the Midi. In Plate 40 it is particularly marked and, as here, it goes with a tendency to treat certain sitters like still-life (which he never painted). Plate 40 represents a new category in his work – a sitter who was neither a patron, a model, nor anyone in Modigliani's circle. Such subjects had the effect of reinforcing the classicism of this period, as they could more easily be generalized. An extreme example is *La Belle Epicière* (Plate 42), where Modigliani's new classic format – sloping or rounded shoulders merging into long neck with small or narrow head – is reduced to its simplest essentials, and the girl's face is hardly characterized at all. Some of the pictures of this classical phase use this generalization to produce an air that is poised and elegant, and breathe a sense of ripeness and satisfaction that belongs to the south. Yet this did not rule out a sharp observation of facial peculiarities when required, as in the portrait of his old acquaintance Gaston Modot.

The paintings done in the Midi should have sold well. They did not, and it seems that there was a virtual conspiracy to hold off until Modigliani was dead. Zborowski actually sold a few things in London at an exhibition organized by the Sitwell brothers in July

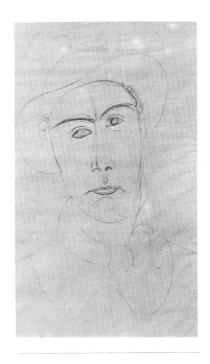

Fig. 10
ANDRÉ DERAIN
Modigliani
PENCIL. 39.5 × 24 CM. C.1919. PARIS MUSÉE NATIONAL D'ART MODERNE, CENTRE GEORGES POMPIDOU

1919. Through 1917 and 1918 there had been a great growth in Modigliani's facility in painting. If he produced repetitious works and attempted pot-boilers, it is remarkable that there were not far more. The irony of the neglect he suffered grew more and more disgraceful, and bit deep into his will and the self-esteem which was so necessary to him. It is usual to associate Modigliani's very last style with his despair and final collapse at the end of 1919. It shows a disturbance of the classicism described above, but signs of this may have begun before the autumn of 1919, perhaps associated with domestic stress. There are two paintings of the

24

pregnant Jeanne Hébuterne reproduced in this book. Plate 47 is probably of autumn 1918, in Nice, when she was carrying the first child. The painting is unusual in its profile composition, which, together with the pronounced swan neck and elongated *coiffure*, give it a rare formal elegance. Yet its exaggeration or mannerism is uneasy and disturbs its calm classicism. Plate 48 is certainly from her second pregnancy in 1919–20. Modigliani may have been working on it in the month he died, as he had on the easel at the time of his death a painting in similar style. The extreme pose, with its twisting movement counterbalanced by a sharp tilt of the head, is a still more mannered version of his earlier restrained elegance, but the disequilibrium of the giddy background with its clash of colours is new and startling.

Modigliani was a key figure in the creation of the mythology of 'modern art'. He did not make the running, as Picasso did almost always, and others at various times. His contribution was not an intellectual or even a pseudo-intellectual one – he could not have founded a theory or started a school. None of,the *peintres maudits* was in this class. Their role was to bypass the academies and the conditioning that made 'fine artists' and give an authentic visual expression of disturbance of the soul, of cultural upheaval. It was necessary for this role that they could handle paint in ways hardly experienced before, and superbly well. Yet Modigliani did have this conditioning, and retained a respect for the traditions which his compatriots, the Futurists, were trying to kill. His special contribution to modern art was to lay this sense of the past, too, at the foot of the great god, the School of Paris. The 'modern spirit' pervaded his work not intellectually but through the air he breathed and the life he led. It is characteristic of 'modern' art that its traditionalism slowly becomes more apparent. The paradox of Modigliani as a traditionalist within modernism was apparent even in his own lifetime. His technical abilities were sound, and though his paintings betray impatience and the constant battering of distractions in his life, he never lost the outlook of a professional and dedicated artist. He was both the victim of modern times and a symbol of the continuity of artistic expression underlying all change.

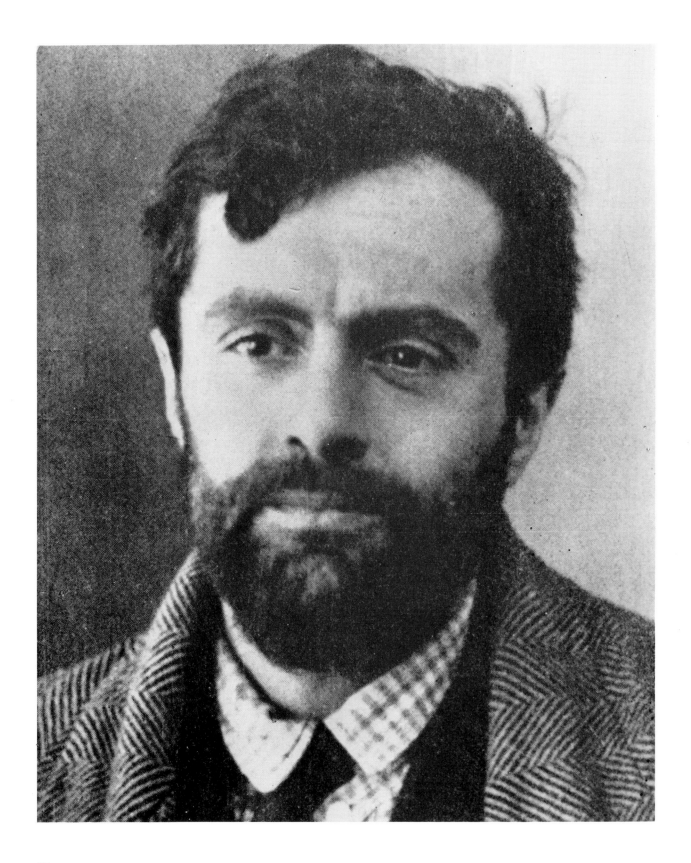

Outline Biography

1884 Amedeo Clemente Modigliani born on 12 July at Leghorn (Livorno).

1895 First serious illness.

1898 Attack of typhoid. Begins to study with the painter Micheli in Leghorn.

1900 Attack of pleurisy leaves him with tubercular lung.

1901 Travelling with his mother in Italy. Writes his youthful philosophy in letters to a friend, the painter Oscar Ghiglia.

1902 Enrols at the Academy of Fine Art in Florence to attend the life school. First evidence of practice of sculpture.

1903 Enrols for the same course at the Academy of Fine Art in Venice.

1906 Arrives in Paris in January.

1907 Meets Dr Paul Alexandre in the autumn, who acquires about twenty-five paintings and many drawings, the last probably in 1913.

1909 Becomes a neighbour of Brancusi, who reinforces his concentration on sculpture. Visit to his family in Leghorn.

1910 Exhibits paintings at the Salon des Indépendants (as also in 1908).

1911 Photographs taken which later prove the existence of sculptures, some still extant today.

1912 Probably in this year returns to Leghorn, obtains stone, and carves, perhaps abandoning the work in Leghorn. But in the autumn, shows seven sculptured heads at the Salon d'Automne.

1914 Meets Beatrice Hastings. Begins to concentrate on painting.

1915 First year with a substantial number of paintings. Paul Guillaume buys and sells some.

1916 Meets Leopold Zborowski who becomes his dealer and supports him with regular payments.

1917 Meets Jeanne Hébuterne, sets up with her in lodgings rented for them by Zborowski. An exhibition at the Berthe Weill Gallery in December closes on the first day by order of the police, who consider the nudes obscene.

1918 Modigliani and Jeanne, Zborowski and his wife, and Jeanne's mother go to Nice. Many paintings this year and in 1919.

1919 Modigliani returns alone to Paris in May. Jeanne and child return end of June. Child put out to nurse. Modigliani is included in an exhibition in London in July.

1920 Death of Modigliani on 24 January. Suicide of Jeanne Hébuterne on 25 January.

Fig. 12
Modigliani shortly before his
Death
PHOTOGRAPH. PRIVATE COLLECTION

Select Bibliography

Ambrogio Ceroni: *Amedeo Modigliani, peintre* (incorporating the memoirs of Lunia Czechowska). Edizioni del Milione, Milan, 1958. Text in French (Ceroni I).

Ambrogio Ceroni: *Amedeo Modigliani, dessins et sculptures* (with an appendix of 65 paintings not reproduced in the previous volume). Edizioni del Milione, Milan, 1965. Text in French (Ceroni II).

Jean Lanthemann: *Modigliani, catalogue raisonné.* Contributions by Nello Ponente and Jeanne Modigliani. Privately printed in Barcelona, 1970.

L. Piccioni and A. Ceroni: *I Dipinti di Modigliani* (*Classici dell'Arte* series). Rizzoli Editore, Milan, 1970.

Alfred Werner: *Modigliani the Sculptor*. Thames & Hudson, London, 1965.

Jeanne Modigliani (Nechtstein): *Modigliani: Man and Myth*. André Deutsch, London, 1959. Translated from the Italian, *Modigliani senza leggenda*. The French version, *Modigliani sans légende,* 1961, has a few extra passages.

Pierre Sichel: *Modigliani*. W. H. Allen, London, 1967. The most comprehensive biography, drawing on a very large number of written and verbal sources.

Charles Douglas (pseud. for Douglas Goldring): *Artist Quarter*. Faber, London, 1941.

John Russell: *Modigliani* (catalogue of exhibition, Edinburgh and London, 1963).

Franco Russoli: *Modigliani*. Thames & Hudson, London, 1959.

Nello Ponente: *Modigliani*. Thames & Hudson, London, 1969.

Jacques Lipchitz: *Amedeo Modigliani*. Express Art Books, London, 1968.

Benedict Nicolson: *Modigliani paintings*. Editions du Chêne, Paris, and Lindsay Drummond, London, 1948.

William Fifield: *Modigliani, the biography*. W. H. Allen, London, 1978.

Carol Mann: *Modigliani*. Thames & Hudson, London, 1980.

List of Illustrations

Colour Plates

Text Figures

Comparative Figures

Head of a Woman Wearing a Hat

WATERCOLOUR, 35 × 27 CM. 1907. BOSTON, MASSACHUSETTS, WILLIAM YOUNG AND COMPANY

The long faced, somewhat grim subject of this drawing is probably the same as the model for *The Jewess* (private collection) and several other early paintings. This was the period of Modigliani's close friendship with Dr Paul Alexandre, and it is possible that he found this model among the latter's patients. Another patient, said to be a young prostitute, posed for two sculpturesque nudes. The subject of *The Jewess* also posed for a half-length nude wearing a large hat, perhaps the one we see in this drawing. Already in these works a certain expressionism, feeding on the study of disadvantaged individuals, can be seen in Modigliani (he met and had long conversations with the young German expressionist Ludwig Meidner at this period). It was a counterpoint to his interest in sculpture. Stylistically, there is nothing remarkable in Plate 1. It comes from a firm graphic tradition and in its combination of a firm outline and flat planes of colour seems to have been inspired by the current art of the poster or even perhaps done with graphic reproduction in mind.

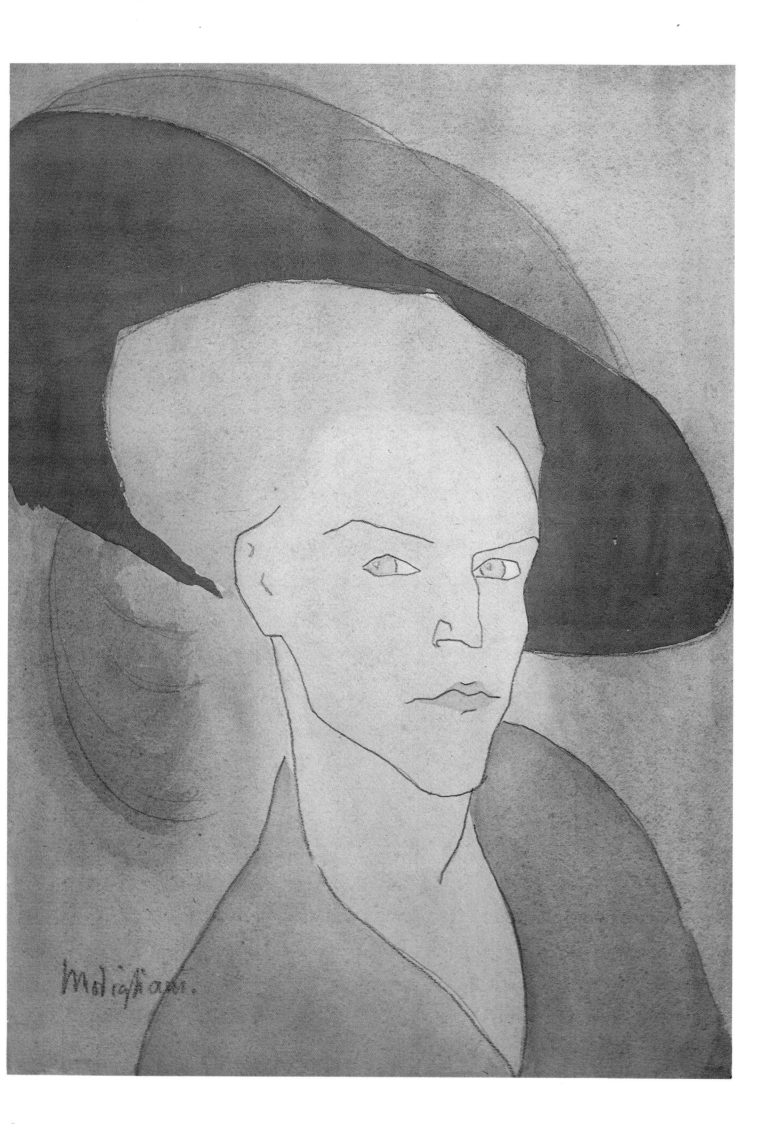

Portrait of Pedro

OIL ON CANVAS, 55 × 46 CM. 1909. PRIVATE COLLECTION

Pedro, thought to be a printer or typographer, must have been one of Modigliani's early acquaintances in Paris. Although the portrait is usually dated to 1909, when Modigliani still considered himself a sculptor, it already shows a straightforward grasp of the principles of painting the head and is not affected by sculptural or linear mannerisms. The even, unshadowed lighting anticipates Modigliani's later portraits, but the volumes of the forehead, cheeks and chin are more firmly modelled by means of colour and tone than his mature style permitted. In the drawing of the features there are already traces of his elegant distortions, and the dark, suspicious eyes are wholly characteristic of his approach. Pedro was presumably a Spaniard, an immigrant and on the fringes of the world of art. Modigliani, who was getting rid of his bourgeois encumbrances, would have met him on equal terms, and the portrait is a reminder that he did his best work when there were no barriers to cross, as there were with the subject of Plate 3 for example.

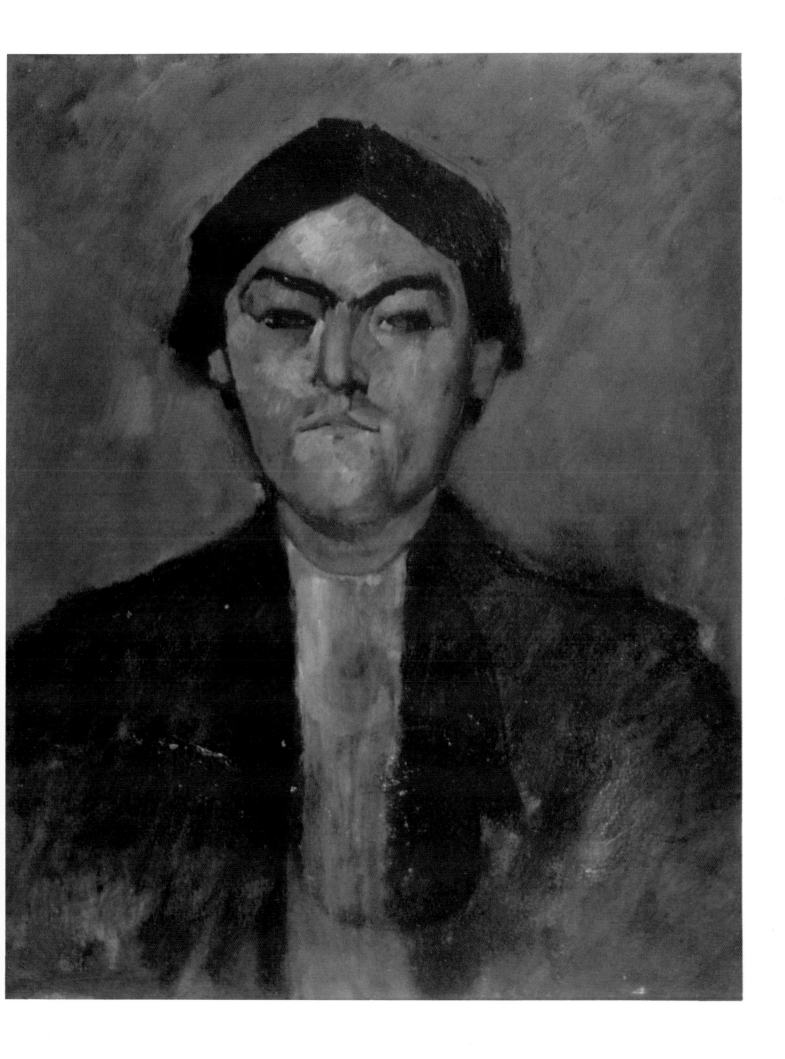

The Horsewoman

OIL ON CANVAS, 92 × 65 CM. 1909. NEW YORK, COLLECTION OF MR AND MRS ALEXANDER LEWYT

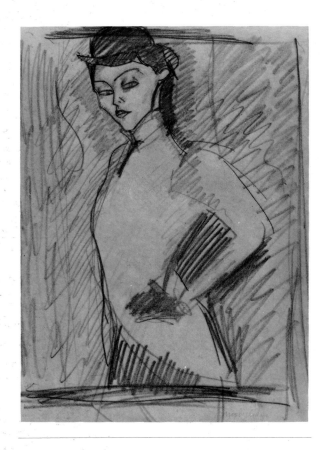

Fig. 13
Drawing for Plate 3

PENCIL, 30 × 22.3 CM. 1909. NEW YORK, COLLECTION OF MR AND MRS
ALEXANDER LEWYT

This painting represents an early effort by Modigliani to become a fashionable portraitist, a role he was fortunately unfitted for. At this date, Modigliani himself might not have recognised that the role was irreconcilable with membership of the *avant-garde*. He did not then, and never fully did so later, accept that he had a special destiny as a revolutionary artist, and was ambivalent about the achievement of the tightly knit group led by Picasso. He still admired Sargent and his own compatriot Boldini, who had started as a *macchiaioli* painter like Modigliani's teachers Micheli and Fattori.

Modigliani obtained a commission to paint a titled lady. No doubt the riding habit was her own choice of dress. The preparatory drawings for the commission (Fig. 13) show a face of Slavonic cast with high cheekbones and slanted eyes. These traits were considerably toned down in the painting. The sitter, however, refused the portrait, and it was bought by Modigliani's only faithful patron, Dr Paul Alexandre.

There is nothing in the general format of the painting that should have offended the lady concerned. More probably, she reacted against the decidedly summary way it is painted, even if the changed outline of the jacket, for example, was not so visible as it is now. The nervy painting of the jacket was already typical of Modigliani's method throughout his life. Even worse, to her, might have seemed the bold lines and touches of the face, quite unlike the melting elegance of Boldini.

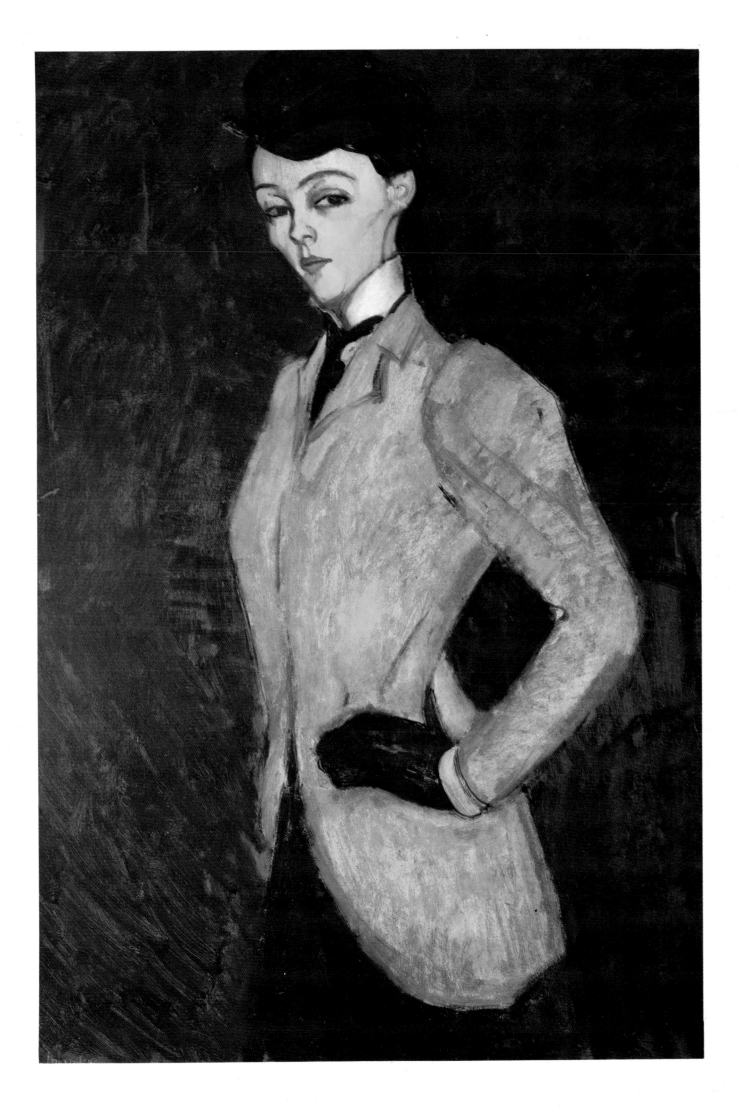

Head

STONE, HEIGHT 45 CM. C.1912. NEW YORK, PERLS GALLERIES

From the age of 18, Modigliani's ambition was to be a sculptor. By his background, personality and physique, however, he was unsuited to this demanding pursuit, and lung trouble eventually led to his giving up carving, by, probably, 1914. Modigliani was reported to have destroyed some of his sculpture on leaving Italy after a visit in 1912; his output was never large, and his surviving sculpture is limited to 23 stone heads and two full-length figures. Even so, there is no clear evidence to show in what order they were executed or how many years' work they represent.

The stone head opposite is rough-hewn if compared with the highly finished head in the Tate Gallery, for example (Plate 14). Yet, there is no evidence that it was carved earlier. It may be unfinished, and thus date from the time when Modigliani was forced to give up carving because of his physical debility. A majority of the sculptures are elongated, but a few are squat and block-like; both types exist in rough-hewn and highly-finished states. The contemporary *avant-garde* theory of sculpture must have seemed to Modigliani to sanction both approaches. When rough-hewn, sculpture looked healthily primitive and mindful of its material, but the polished kind was reminiscent of certain kinds of highly-wrought African carving.

The relationship of Modigliani's painting to his sculpture remains a puzzle. Here, the small features lightly incised in the stone recall a certain type of painting and drawing of 1914 and 1915, of which Plate 5 is a good example; his other sculptural styles also have their equivalent in painting (Plates 14 and 15).

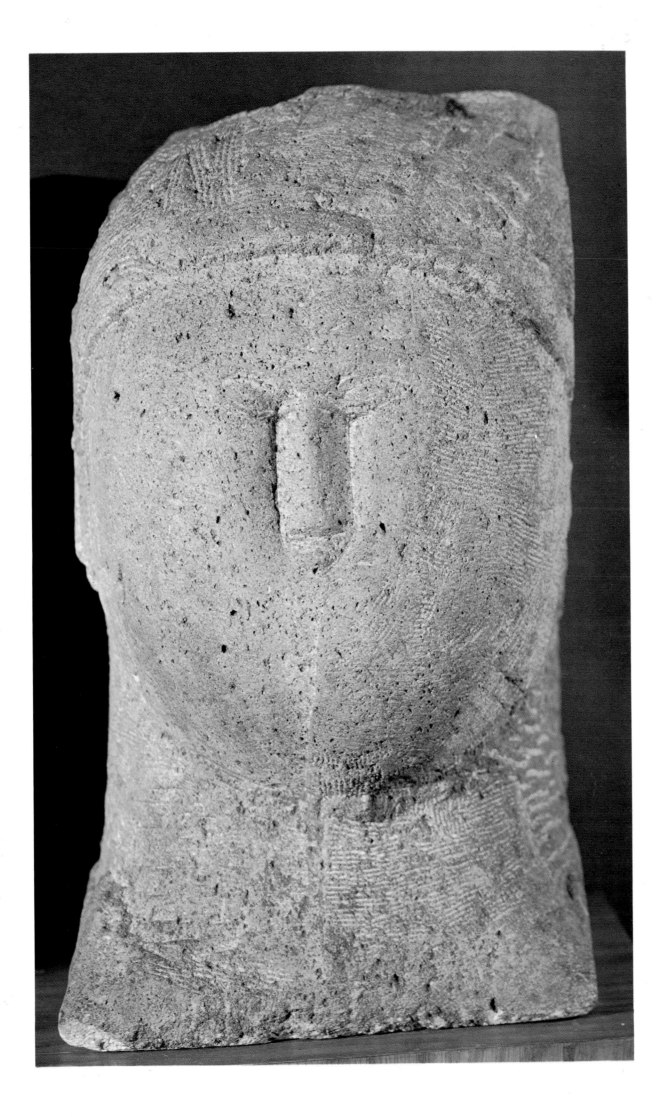

Portrait of a Woman

OIL. 1915. NEW YORK, PERLS GALLERIES

This painting and Fig. 14 belong to a particular group in Modigliani's work, which was executed in the form of ink drawings, in gouache or in oil, as in this example. They are all distinguished by an economical, seemingly tentative use of the medium, which is applied dryly in touches and dots. This is in strong contrast to the extremely fluid, cursive line of Modigliani's better-known drawings. The group is associated with the year 1915, when he had finally changed his ambitions away from sculpture to painting, but it may have begun earlier, for it is certainly connected with the change of medium. These works, all of which are heads, present a two-dimensional equivalent of certain sculptures such as Plate 4, the mass of the face being lightly marked out as if by light taps of the chisel in the stone. Modigliani, however, uses the presence of the paper or canvas to add fanciful or real names such as Rosa Porprina or Mateo (Alegria) (Fig. 14).

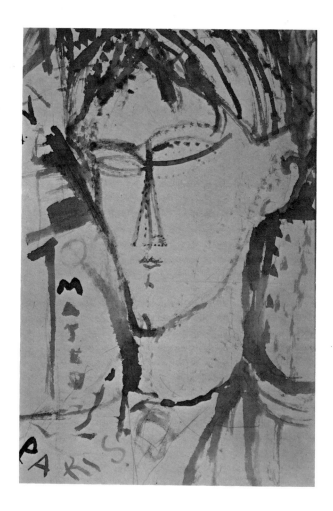

Fig. 14
Mateo Alegria

BRUSH AND INK WASH, 49.5 × 32.4 CM. 1915. PRINCETON UNIVERSITY, THE ART MUSEUM

Head

STONE, C.1911. NEW YORK, PERLS GALLERIES

Modigliani's early passion for sculpture is mysterious, as he received his first training among well-established Italian painters of the time. Perhaps, during his youthful travels with his mother in Italy, he decided that these painters did not represent the Italian tradition as he loved it, which he found instead in the wealth of mediaeval, Renaissance and modern marble carving in the places he visited. As soon as he could get away from home, he took lodgings in the marble-working town of Pietrasanta and apparently produced a sculpture there, but we do not know what it was like. That was in 1902.

Plate 6, however, is not a pastiche of traditional sculpture, not even an unskilled one. Its simple shapes and somewhat expressionless features may seem like the work of an inexperienced carver, but they are also assured and sophisticated. To produce this work, something else was needed, namely an understanding of primitive art and of its relationship to the modern. This understanding could only have been acquired in Paris. All the pioneering modern sculptors before the first war had spent time in Paris, and all had been influenced to some degree by primitive art. Modigliani's sculpture shows this influence in its most generalized and elegant form. This work seems to have come from the archaic roots of European sculpture, rather than from the more recent work of Africa or Asia.

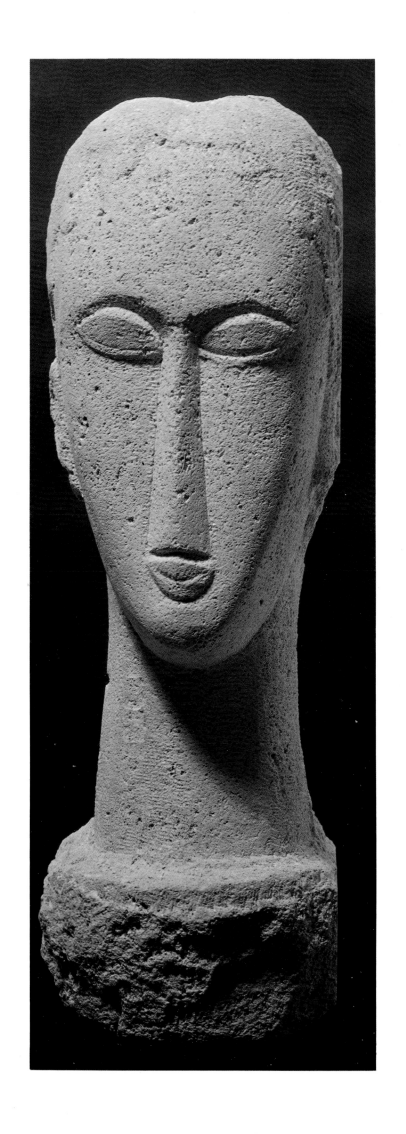

Standing Nude

OIL ON PAPER, 83 × 48 CM. C.1911. NEW YORK, PERLS GALLERIES

The considerable number of sculpture-related drawings by Modigliani present a confusing abundance and variety, yet their subject-matter is not so diverse as it might seem. Very many are highly formalized heads, there is a large group of kneeling or crouching female figures (see Plates 8, 9 and 11), and a smaller number of erect full-length nudes. Plate 7 is an unusually elaborate example of these, reinforced with oil colour, in which Modigliani sets himself to produce an image that could easily be converted into sculpture (he even put in the round pedestal). Its odd proportions conform to a primitivistic standard, seen also in the sculptures of Lehmbruck and Archipenko. The drawing corresponds closely to the sole surviving erect full-size figure in stone, but that is of more massive and yet more primitive proportions, with a much longer head. Like most of Modigliani's actual carvings, it too is unfinished. See Plates 10 and 11 for a similar comparison between Modigliani's conceptions of sculpture as expressed in drawing and their laborious realization in stone, when he was frustrated by the nature of the material and his own inexperience. Only in the heads was he able to overcome these difficulties.

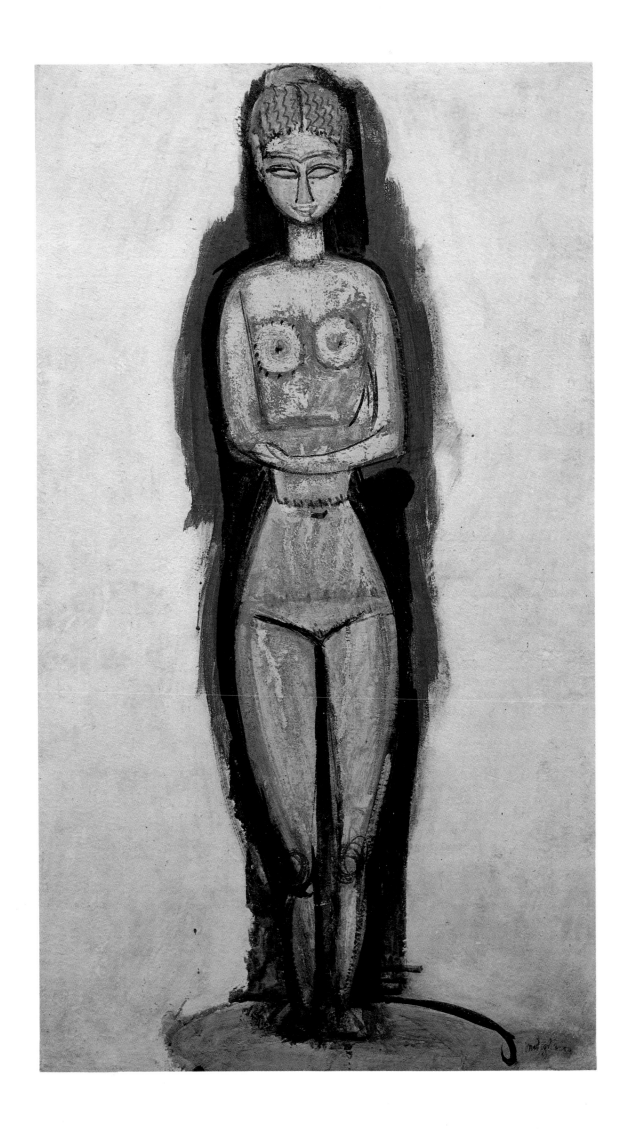

Caryatid

WATERCOLOUR, 83 × 43 CM. C.1913. PRIVATE COLLECTION

Fig. 15
Robed Figure, in Profile to the Left ('Dessins à Boire')

PENCIL, 35 × 25 CM. 1915. FORMERLY CHESTER DALE COLLECTION

The group of drawings of women with arms above their heads as if supporting something, therefore known as 'caryatids', are pre-eminent for their size and beauty. Often, as here, they are in pencil reinforced by watercolour or crayon. This example is unusually large because it was extended by separate pieces of paper at top and bottom. Unlike Plate 7, these drawings are not in a direct way studies for sculpture (see Plates 10 and 11). The figure in Plate 8 could not be carried out in stone, and would cause great technical difficulties in any medium. It is, therefore, no more than an evocation of a certain spirit in modern art, in the development of which sculpture had played a significant part. Brancusi is obviously an influence, but behind the svelte and beautiful outline, rendered with such discretion and delicacy, there is also the effect of primitivism in its widest sense, embracing the knowledge of both African and Indian sculpture.

Direct observation of the human model, which Modigliani used to such effect in the series of paintings of the nude in 1917, does not play much part here. There is, however, a group of drawings in which Modigliani imposed a classical, sculptor's, sense of order on more direct experience, even in the worst of circumstances. On the beautifully spontaneous yet restrained drawing of Fig. 15 someone has written *dessins à boire*, indicating that it was one of the rapid drawings Modigliani made in cafés for the price of a drink.

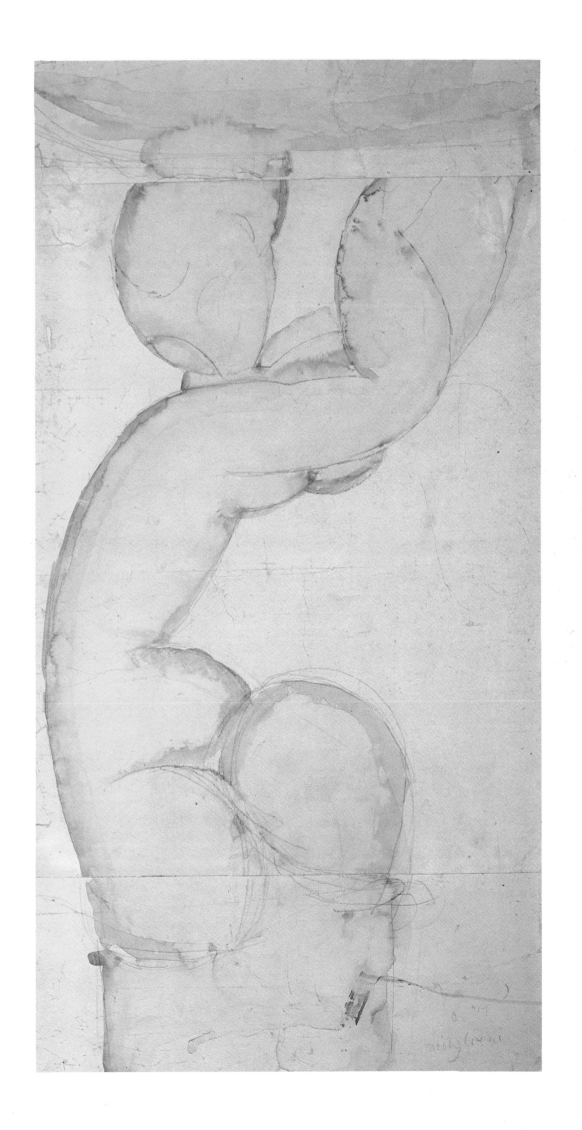

Caryatid

CRAYON. C.1913. NEW YORK, PERLS GALLERIES

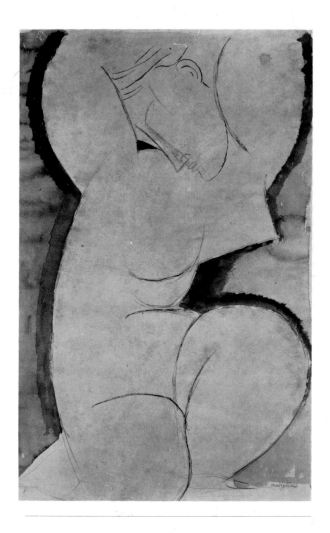

Fig. 16
Caryatid
PENCIL AND WATERCOLOUR, 53.5 × 41 CM. C.1913. THE ART
INSTITUTE OF CHICAGO

If less elegantly beautiful than Plate 8, this drawing is more forceful and also more erotic. The pose of the legs, with the foot tucked under the crotch, seems to be directly borrowed from the repertory of Indian erotic art. At the same time the upper part of the figure is definitely European and modern. The arms joined behind the head is a device that Picasso had used in *Les Demoiselles d'Avignon* and a few other smaller works deriving from it. The profile of the breasts suggests a modern sexual sensibility, and the tiny delicate lines with which Modigliani has marked out the nipples and navel show that he was not really thinking of the broad statements of directly carved sculpture.

There is a sharp division in Modigliani's work between all that pertained to his career as a sculptor, and all that concerned his more popular image as a painter of Bohemian Paris. In the first category comes everything that truly singles out Modigliani as a modern artist, yet there are too few works, and their chronology too obscure, for us to be certain what Modigliani's contribution to the movement really was. Plate 9, although firmly in the sculpture 'camp', is one of a few drawings that come close to bridging the gap in his work. Fig. 16 is a drawing of similar character, based on sensual data although more formalized in the breast and arms and especially in the way the head is joined to the body. Instead of the Brancusi-type head of Plates 8 and 9, it shows a head of Modigliani's own type, which he worked out in sculpture (Plate 14), and for a time attempted also to use in painting (Plate 15).

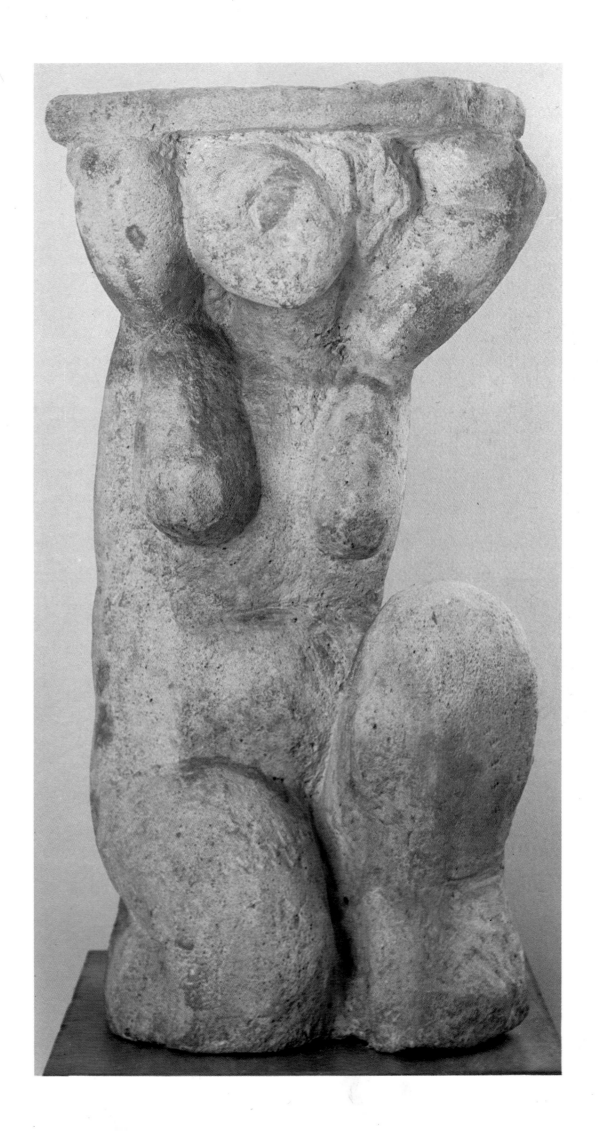

Caryatid (Audace)

GOUACHE, 60 × 45 CM. C.1913. WEST PALM BEACH, FLORIDA, NORTON GALLERY AND SCHOOL OF ART

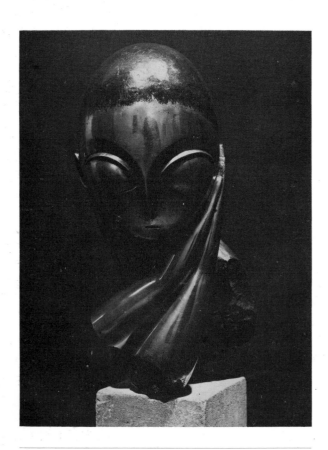

Fig. 17
BRANCUSI
Mademoiselle Pogany (Version 1)
BRONZE, 44 CM HIGH. 1913. NEW YORK, MUSEUM OF MODERN ART

Among the series of large and impressive coloured drawings related to Modigliani's sculptures, this is one of the boldest and the most three-dimensional. 'Related' to the sculpture is a question-begging word, but in fact it is uncertain what Modigliani's precise intentions in making these drawings were. They are so numerous in comparison with his tiny output of actual sculpture, and so little capable of being used as working drawings, that it is tempting to think Modigliani used them as a surrogate for the sculpture he knew at heart he would never make. On the other hand, he may have genuinely thought he was amassing ideas for an ambitious project, of which he sometimes spoke, for a temple sustained by caryatids. If the caryatids were all to be different, it would explain the variety and number of the drawings, while the realization of the project was far enough away for Modigliani not to worry about more practical preparatory studies.

We have seen in discussing Plate 10, a caryatid that Modigliani actually executed although on a modest scale, how for practical reasons it had to differ greatly from the drawings. Yet Plate 11 is as close to it as the drawings go, and Modigliani has gone to some trouble to make it look in the round, far more solid and detached from the background than Plate 8 or Plate 9. It is also more revealing of the artist's method of drawing and of his state of mind at the time. Note how the pencil moves freely in overlapping arcs especially in the arms. The head is a splendid example of the 'Brancusi' type, which prompts comparison with the Rumanian sculptor's huge-eyed *Mademoiselle Pogany* (Fig. 17).

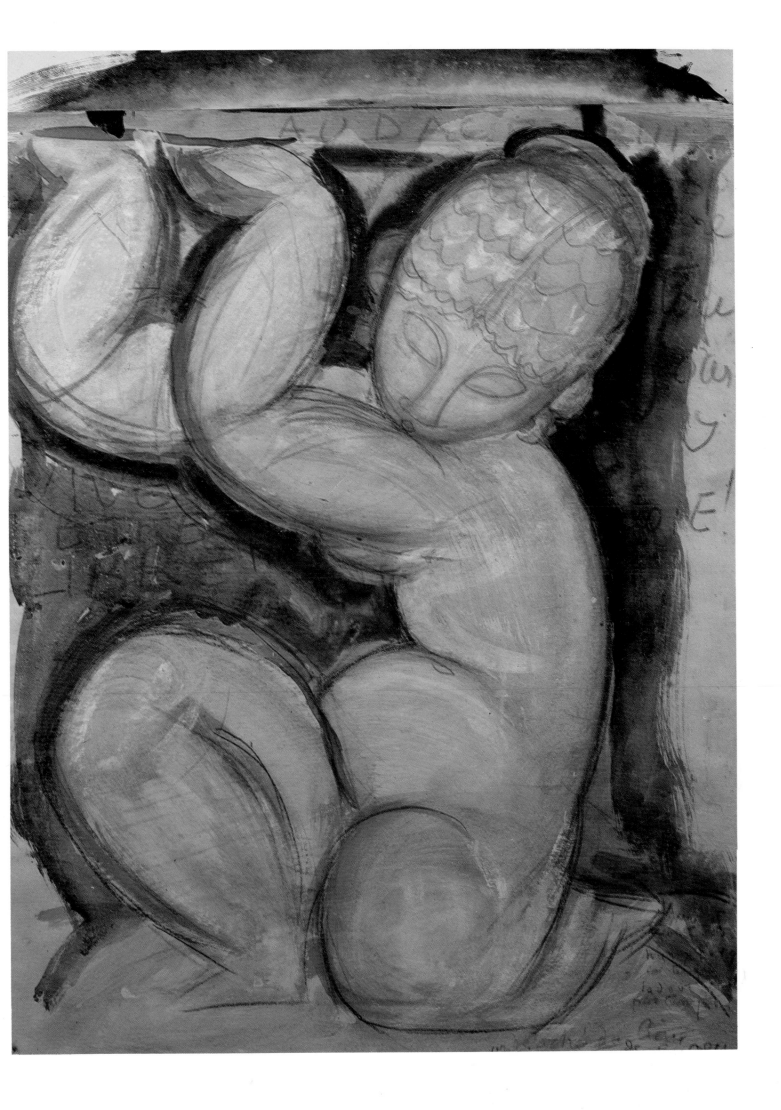

Head

STONE, HEIGHT 64 CM. C.1911. NEW YORK, THE SOLOMON R. GUGGENHEIM MUSEUM

Many of Modigliani's carvings seem to have been done with architecture in mind. They are columnar and resemble heads of caryatids. Like other artists of the period, Modigliani dreamed of doing great things, and of great projects that would unite different arts in a grandiose whole. Few such projects were ever carried out, and Modigliani was even less fitted than most to realize one. The nearest he came to it was when he exhibited seven stone heads together at the Paris *Salon d'Automne* of 1912, when they were catalogued simply as *Heads — a decorative ensemble.*

Although primitive art was a pervasive influence in advanced artistic circles before the First World War, the influence was not all in one direction. For some artists, it was the vivid expressionism of primitive sculpture that counted. Other artists drew from it the principle that form alone was important in sculpture, and that form should be the most simplified yet subtle echo of the natural subject that inspired it. A kind of archaic simplicity was the keynote for the few modern monumental sculptures that were executed. This is the note that Modigliani tries to strike with this head, although its slender, almost chic elegance conflicts with the usual conception of a monument.

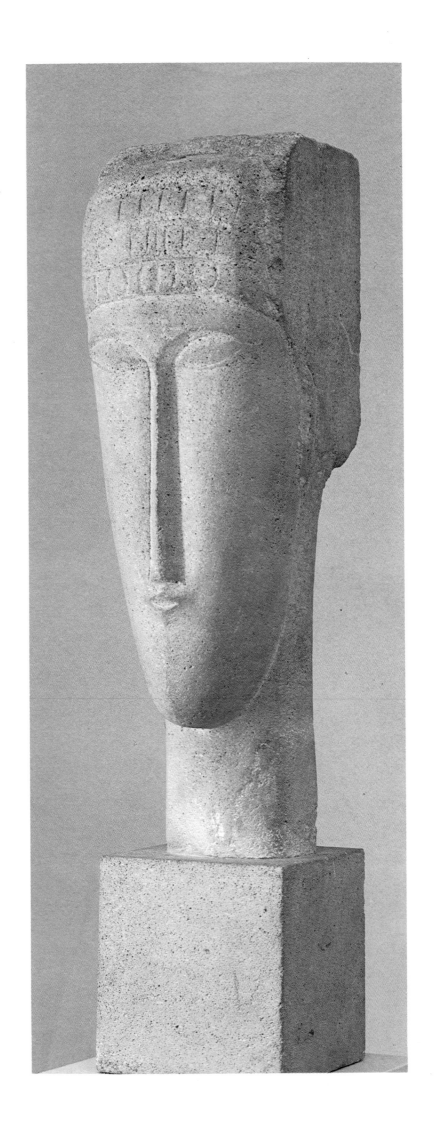

Head

STONE, HEIGHT 58 CM. C.1911. PARIS, MUSÉES NATIONAUX

Comparison of this head with that in Plate 14 shows the great variety of expression that Modigliani was able to impart to the carved heads, which seem to conform so closely to a type. Where some heads are only elegant, somewhat empty and almost chic and fashionable, a few such as Plate 13 have a brooding, enigmatic quality. Modigliani drew on a number of primitive, exotic or archaic sources to develop his repertory of images. Here the enigmatic smile, the flat nose, rounded forehead and details of the hair, suggest a perception of Chinese art. Most of Modigliani's sculptures retain some of the surface of the original block, which here forms the whole back of the carving. This may be because of Modigliani's limited physical powers as a sculptor, for it saved his labour. But it also serves to remind us that these pieces are conceived architecturally, and some could easily take their places in a building as corbels or keystones. This was perfectly in keeping with the views of the pioneer carver-sculptors like Epstein.

The drawing (Fig. 18) illustrates the difficulty of relating Modigliani's drawings and sculptures in a satisfactory way. Is the resemblance more than superficial? The lump of hair at the top of the drawing, resembling the raised piece of stone in the sculpture, is a later addition. Even the relation of the drawing to life is uncertain. It is interesting, however, as bridging the gap between observation (e.g. the earring) and the formalism of the sculpture.

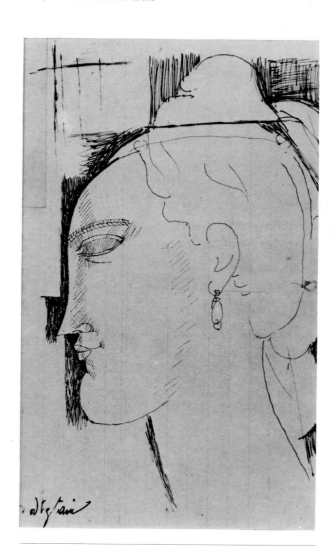

Fig. 18
Head of a Woman with an Ear-ring
PEN AND INK ON LINED PAPER, 18.5 × 11.8 CM. C. 1913. DIJON, MUSÉE
DES BEAUX-ARTS

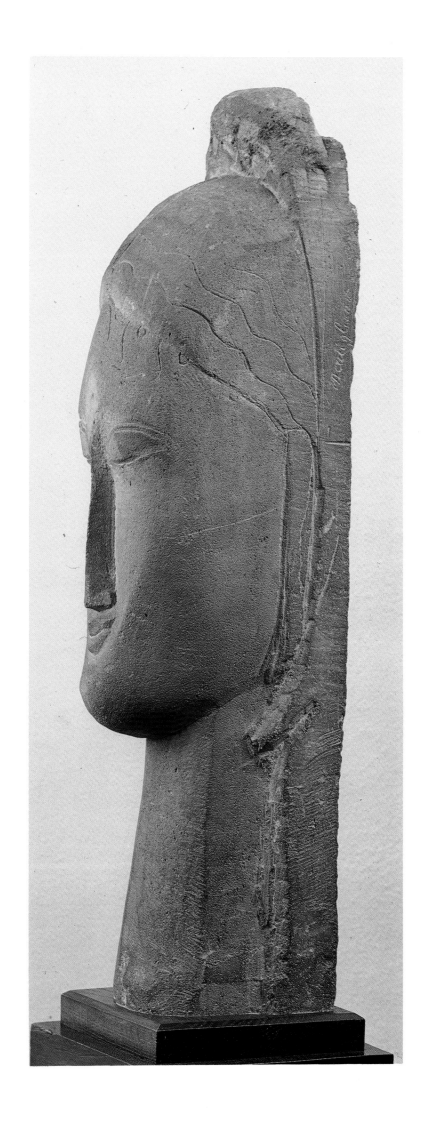

Head

STONE, HEIGHT 88 CM. C.1911–12. LONDON, TATE GALLERY

Where Plate 13 has reminiscenses of Chinese restraint, Plate 14 has quite different resonances. We think of the more sophisticated African tribal carvings, even a little of Cycladic sculpture or, most basic of all, the shape of stone axes or later artifacts refined by generations of traditional use. In its form, this is one of Modigliani's most beautiful carvings, but it has also a more pronounced architectural character than most, perhaps just because it is so formalized as a human image. What is the sex of these carved heads? It is strange that Modigliani who was so sensual in his appreciation of the opposite sex should have produced these images of a sexless nature. This too would have been quite in keeping with other pioneers. Who would ascribe a particular sex to Epstein's *Sunflower*, for example?

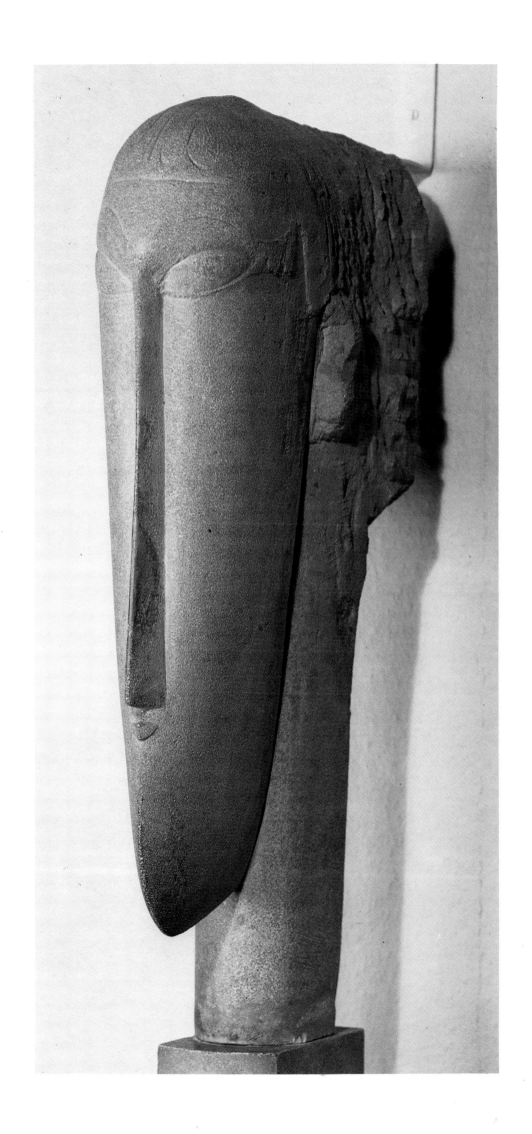

Pierrot

OIL ON CARDBOARD, 43 × 27 CM. 1915. COPENHAGEN, STATENS MUSEUM FOR KUNST

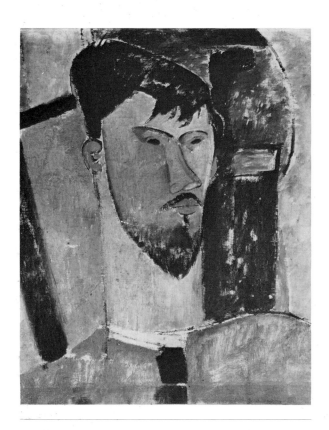

During 1915, if the accepted chronology of Modigliani's work is correct, Modigliani had finished with sculpture and was trying to establish himself as a painter. The paintings of this year include some that are very close to the sculpture, and others that are as non-sculptural as he ever painted. *Pierrot* has the columnar neck, the long pointed face, and hair massed on top that are familiar from the sculpture. It is also evident in this work that although Modigliani had not yet painted much, he had drawn a great deal. In the many drawings for sculpture, he had used a sharp continuous line exactly defining the profiles and changes of plane. Now, appropriately to the different art form, the line is broken and impressionistic, and has acquired an independent life of its own.

In *Pierrot*, which purports to represent a type, not an individual, the echo of the sculpture is clear and authentic. Modigliani had rather more difficulty with portraits of individuals such as the highly characterized *Henri Laurens* of the same year (Fig. 19). Here the immense neck seems a purely formal device, supporting a face that itself is more robust than elegant. Apart from the neck, the other parts of the portrait are realized with purely painterly means.

Fig. 19
Henri Laurens
OIL ON CANVAS, 55 × 46.5 CM. 1915. PARIS, PRIVATE COLLECTION

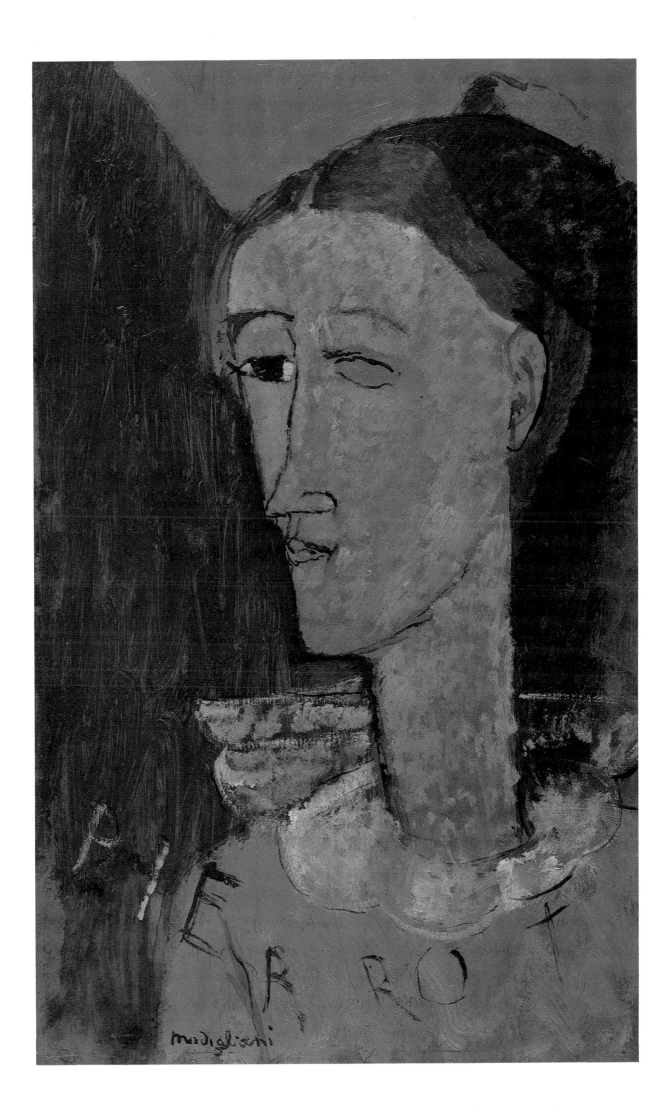

Diego Rivera

OIL ON CANVAS, 100 × 81 CM. C.1914. PRIVATE COLLECTION

Modigliani executed several drawings and paintings of the Mexican painter (b. 1886), whose massive head and small features bear an uncanny resemblance to some of Modigliani's sculptures (Plate 4). The few paintings of 1914 are tentative and experimental in character. In this example he seems to have gone as far as he could in the direction opposite to his sculpture. The head emerges luminously from a dark background, which is obscured still further by a mass of brush strokes half defining the body and the right hand of the sitter. The head of another figure is dimly discernible in the top right hand corner. Only in the work of Modigliani's older compatriot, Medardo Rosso, did sculpture ever approach such an effect. Such work had very little to do with any advanced modern painting then going on in Paris. Despite its loose execution and freedom from convention, the Diego Rivera portrait is still fundamentally romantic, using brushwork to create an impression that is both fleeting and stylized. Comparison with the drawings, (a splendid example is Fig. 20), however, shows that together with the stylization Modigliani achieved remarkable fidelity in portraying his sitter's features.

Fig. 20
Diego Rivera
PEN AND INK, 26 × 20.3 CM. 1914. THE ART INSTITUTE OF CHICAGO

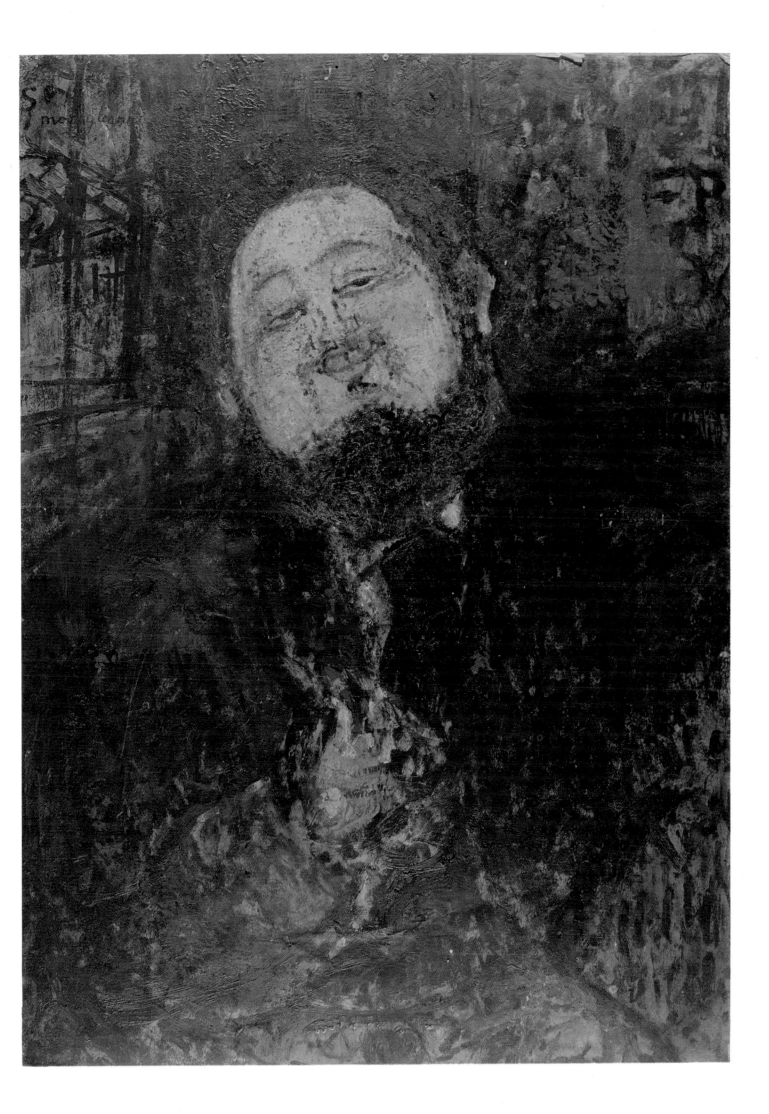

Study for Portrait of Frank Haviland

OIL ON CARDBOARD, 61 × 50 CM. 1914. LOS ANGELES COUNTY MUSEUM OF ART

Although not similar in technique, the portraits of Diego Rivera (Plate 16) and Frank Burty Haviland form a natural pair. Both date from 1914, both are experimental and painterly in their different ways, seeming to turn their backs on Modigliani's sculpture. Both are of men of very singular appearance. How far did Modigliani distort and exaggerate the appearance of his sitters? Was he attracted by striking-looking people? No doubt that he was, or that he accentuated their peculiarities; but the independent evidence seems to show that Modigliani got a very good likeness. He was, in fact, a superb caricaturist — a fact usually overlooked. Nevertheless, one might well doubt the likeness of the Haviland portrait. There exists, however, a preparatory drawing (Fig. 21), which has the appearance of a careful study from life, yet the profile is almost identical to that of the painting. A similar relationship can be seen in all cases where drawings for portraits are known. It seems that Modigliani's distortions were so much a part of his vision that they flowed directly into his drawings, and were ready for transfer for the painting with little further alteration.

As a painting the Haviland portrait is more recognizably up-to-date than the Rivera, *Haviland* being executed in a half-divisionist, half-fauve manner, though with little understanding of the techniques involved.

Fig. 21
Frank Haviland
PENCIL, 27.5 × 21.5 CM. 1914. MUSÉE D'ART MODERNE DE LA VILLE DE PARIS

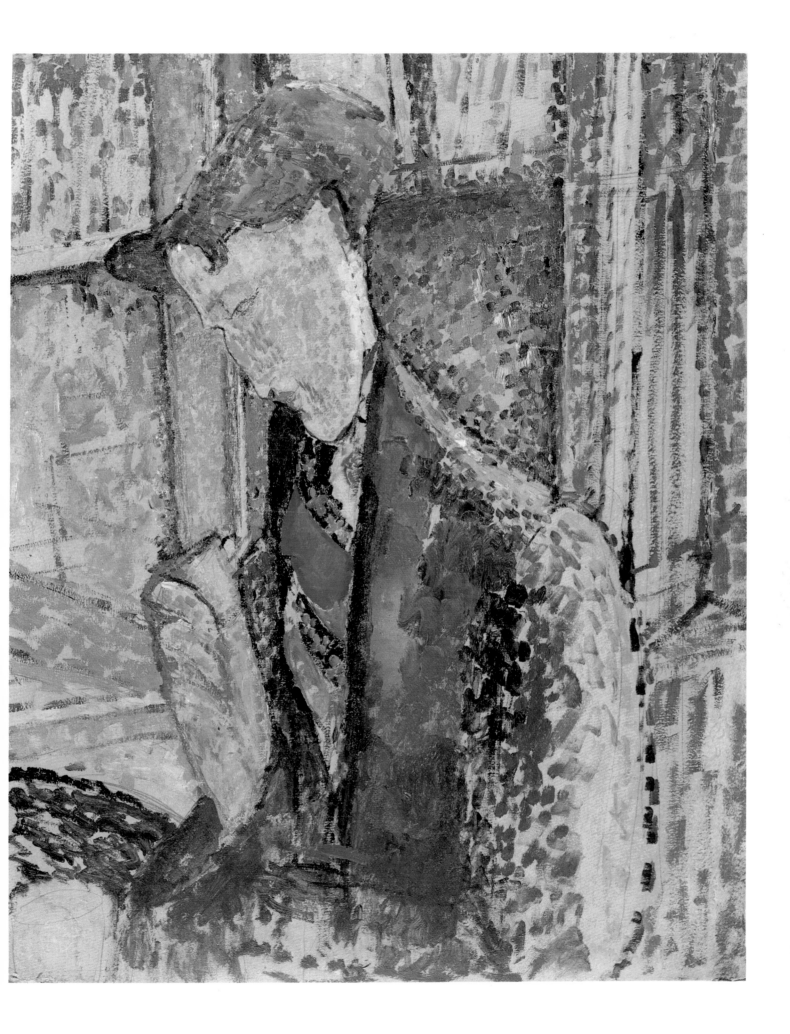

Beatrice Hastings

OIL ON CARDBOARD, 55 × 46 CM. 1915. TORONTO, ART GALLERY OF ONTARIO

Strangely, this likeness of Modigliani's companion during two stormy years is among the blandest and most expressionless of his portraits, in which formal considerations have taken precedence over the wish to characterize the sitter. In its simplicity of outline and internal modelling, it seems to hark back to Modigliani's sculptural ideal, an effect deliberately mitigated by the busy effect of the chairback, which, moreover, disappears where it should continue over the sitter's right shoulder.

It is by no means certain that all the paintings and drawings of Beatrice Hastings have been identified, but the known ones lack Modigliani's usual sharp facial analysis, though they may show Beatrice's interest in clothes or hats. The most revealing by far is the drawing identified by Modigliani himself as Beatrice, showing her naked in the erotic pose of holding a garment round or just below the hips, as if about to step out of it (Fig. 22). The face has a portrait character; the woman looks down and away with a hint of sexual submission, which was no doubt intended by artist or subject to be highly provocative. There is another drawing of a woman in the same pose but without the personal character, inscribed *La femme pauvre* (the poor woman). The named drawing is the only evidence of Modigliani's sexual relationship to Beatrice, who cannot be certainly identified in any of the paintings of the nude (but see Plate 26).

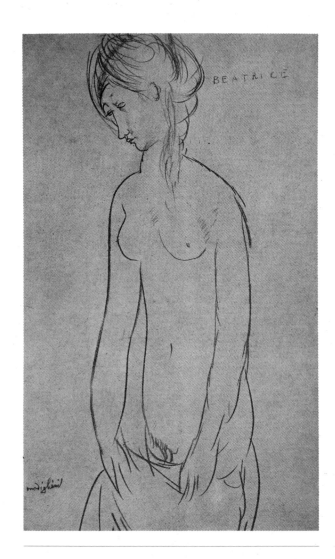

Fig. 22
Beatrice
PENCIL, 55 × 38 CM. 1916. PARIS, PRIVATE COLLECTION

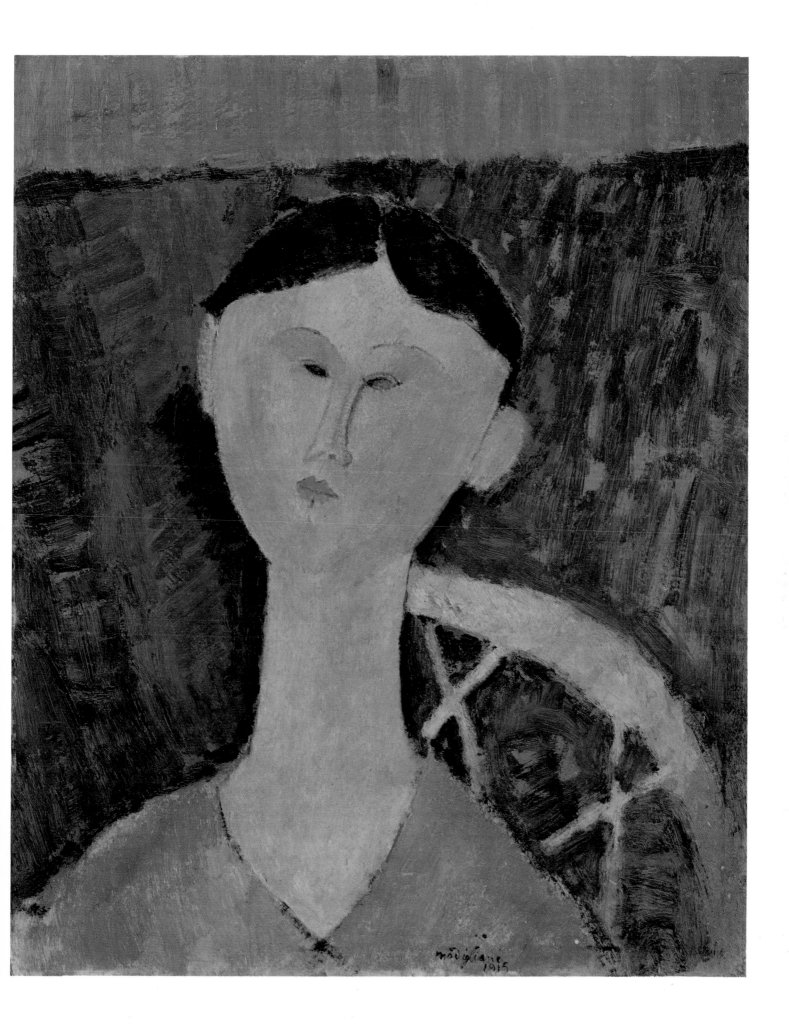

Antonia

OIL ON CANVAS, 82 × 46 CM. 1915. PARIS, MUSÉE DE L'ORANGERIE

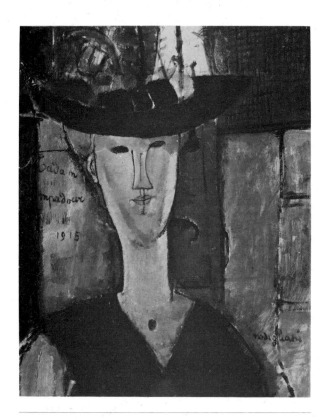

Fig. 23
Madam Pompadour
OIL ON CANVAS, 61 × 50.4 CM. 1915. THE ART INSTITUTE OF CHICAGO

In 1915, Modigliani was still experimenting with methods of painting that could be called 'modern' and were not purely directed to characterizing his subjects. The influence of his sculpture was still strong. For painting the features of a face, Modigliani had developed a certain formula, which has been called, very loosely indeed, 'cubist'. He accentuates the centre line of the face, often painting an actual line through the mouth. There is always a button mouth with small lips sharply defined at the edges. The nose is often defined by a straight line on one side and a curved line on the other, giving the impression that it is half in profile. The eyes too are commonly small, almond-shaped and blank, without eyeballs. All the features are linked in a simple linear device or diagram, which is placed within the oval of the face. The device limits the range of facial expression in the paintings of this time compared with those of 1917–19. However, the element of caricature is already strongly present. In *Madam Pompadour* (Fig. 23), which is probably a portrait of Beatrice Hastings, Modigliani half celebrates, half satirizes, her pride in possession of an elaborate hat (see also Plate 21).

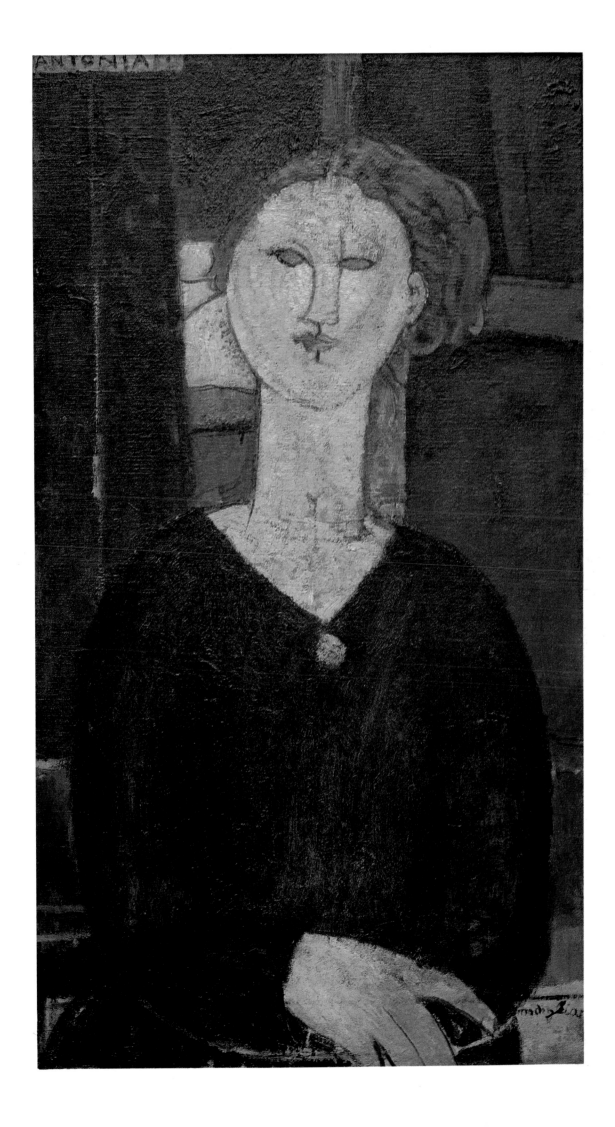

Celso Lagar

OIL ON CANVAS, 35 × 27 CM. 1915. PRIVATE COLLECTION

In this small portrait of a young Spanish painter, Modigliani has put aside the formula described for Plate 19, and thereby produced a work that is both more substantially modern and also more expressive — to the point of being disturbing. The lines and planes of the face are quite brutally twisted in a spiral movement from right to left, the mouth is open, the eyeballs are shown, so that the man moves, sees and speaks. Naturally, Modigliani's characteristic distortions are still present, but in this unusual work he shows himself capable not just of caricature but of a surprising expressionism. *Celso Lagar* belongs to Modigliani's so-called 'cubist' period. While 'cubist' is really a misnomer, it is true that there is a basic stylistic device of modern art underlying the success of this portrait; that is, the freedom to superpose different aspects of the thing represented in the same image. Here we hardly notice the profile turning into the full face, but the effect of the device can be gauged very simply by covering parts of the face in this plate with your hand.

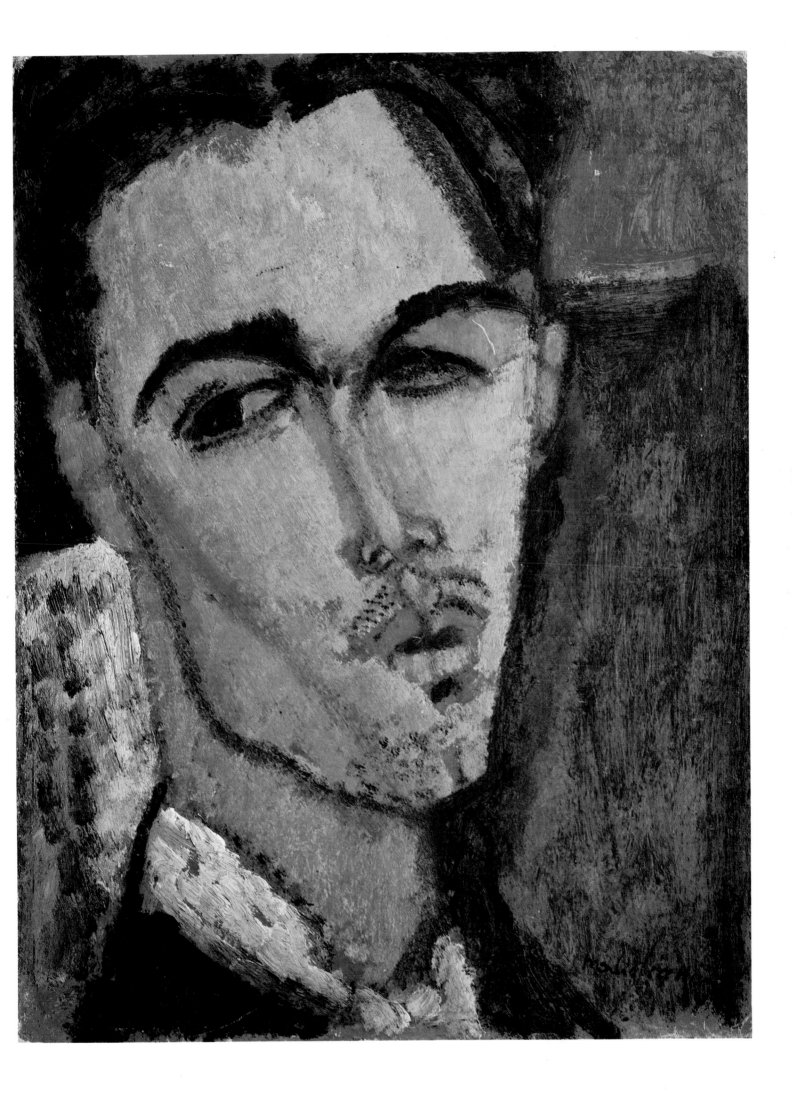

The Bride and Groom

OIL ON CANVAS, 55 × 46 CM. 1915–16. NEW YORK, MUSEUM OF MODERN ART

One of Modigliani's few double portraits, it is also one of the most formalistic, and at the same time most comic, of his canvases. The man's face is an extreme example of the 'formula' already described for Plate 19, to which the woman's features also conform. Far from hindering Modigliani in conveying the inanity he saw in the couple, the woman vulgar and silly, the man stupid and pompous in his boiled shirt, the formula, in fact, expressed it very well. This was the time when Modigliani's personal disasters were starting, and his experience of society becoming more obsessive. At the same time he was selling his work to a dealer, Paul Guillaume (Plate 23), and may have been under some pressure to produce a run of acceptable paintings. A formula, which he could repeat and which at the same time conveyed his feelings about humanity, would have been very useful to him at this period. As the *Celso Lagar* (Plate 20) shows, Modigliani was well able to rise above it if he tried.

The drawing of the man's features in *The Bride and Groom* raises the question whether Modigliani might have seen the work of Paul Klee, as the moustache, for example, is worthy of the Swiss-German master. Yet the comic effect is more purposive than that of Klee, in whom humour welled up irresistibly. *The Bride and Groom* is highly structured, for Modigliani, in a rectilinear way and seems to represent a deliberate effort towards a fashionable modernity.

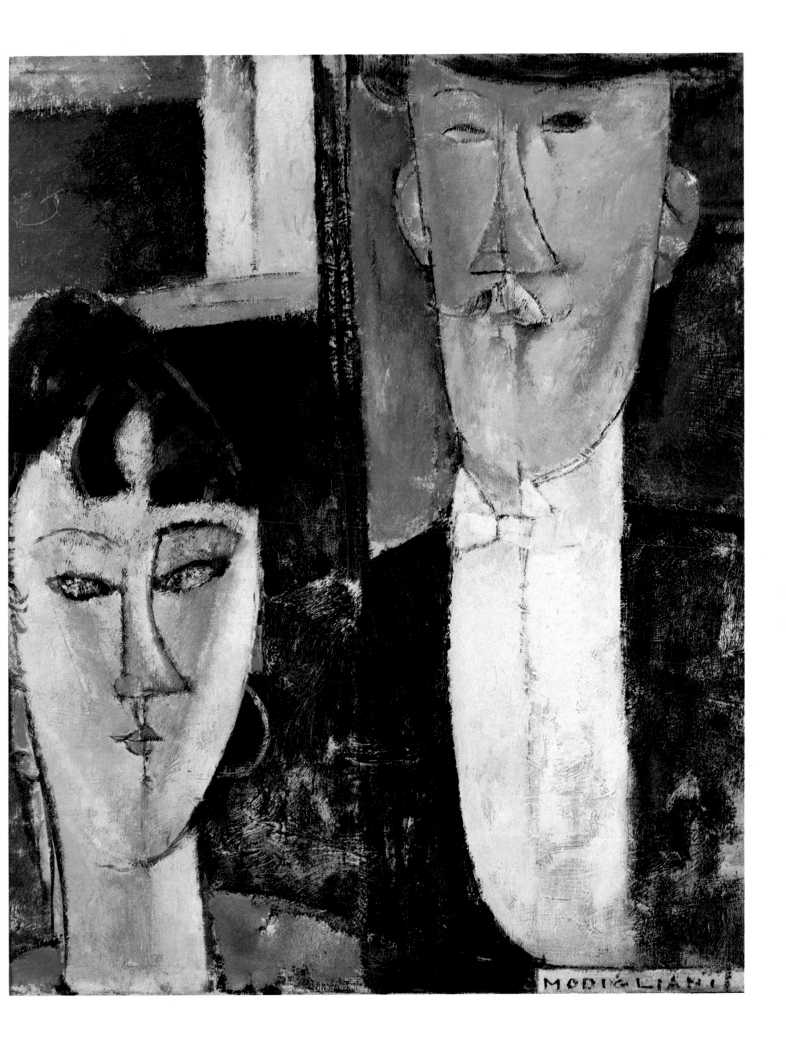

Jean Cocteau

OIL ON CANVAS, 100 × 81 CM. 1916. NEW YORK, HENRY AND ROSE PEARLMAN FOUNDATION INC.

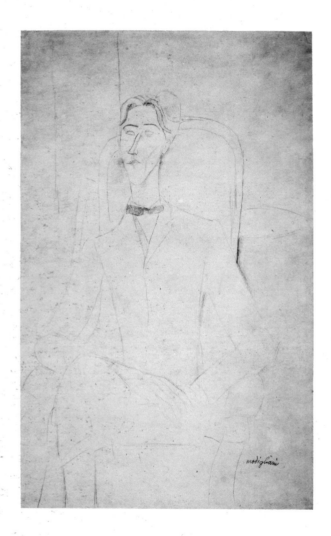

The polymath Jean Cocteau (1889–1963), though then only about 27, must have been one of the most remarkable sitters Modigliani ever had, for he inspired one of the most remarkable portraits. It is arranged with unusual deliberation in a space painted with special care. The precise upright pose of the sitter in his formal clothes may represent Cocteau's estimation of himself as a high priest of culture, but must also reflect the somewhat ironic image Modigliani had of him. In style, like other works of 1916, this portrait is transitional between Modigliani's so-called 'cubist' portraits, and the more 'classic' portraits of 1917–19. Some aspects of the 'formula' remain here and were to recur throughout Modigliani's short career — the characteristic elongation, the button mouth, the nose represented in profile — but these features are now more thoroughly modelled and integrated into the volume of the sitter's head, instead of being merely drawn on its surface.

A preparatory drawing (Fig. 24) shows that in the painting Modigliani has stiffened and rendered more frontal the comparatively relaxed and graceful pose of the sitter at the time.

Fig. 24
Jean Cocteau
PENCIL, 42.1 × 26.3 CM. 1916. AMSTERDAM, RIJKSMUSEUM

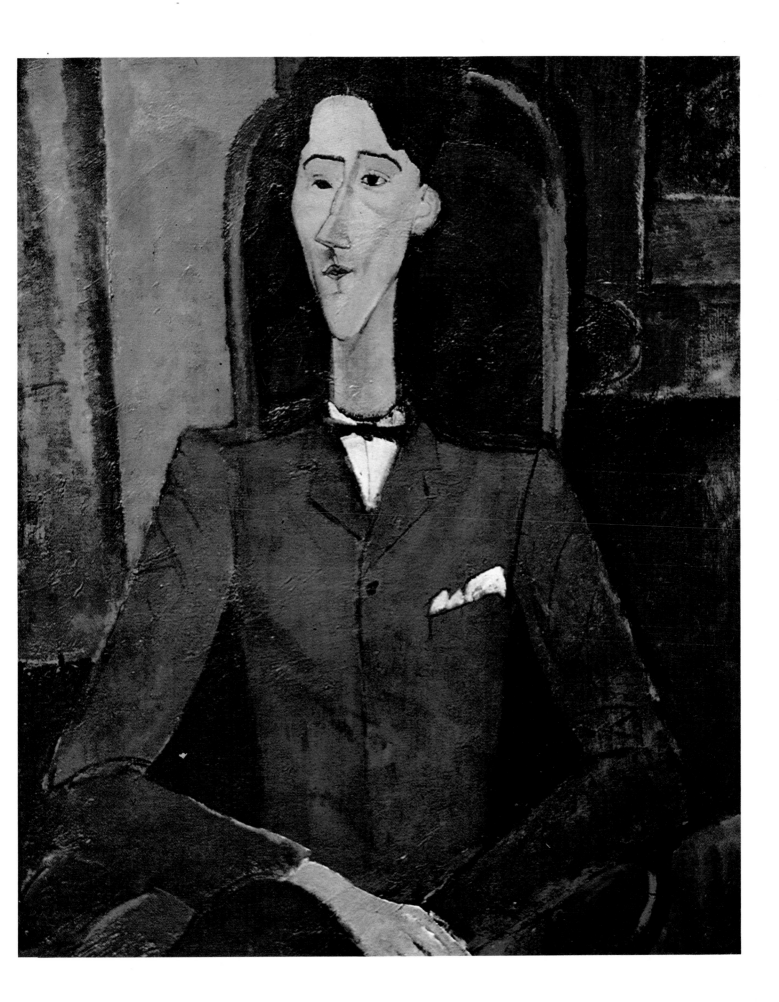

Paul Guillaume

OIL ON CANVAS, 81 × 54 CM. 1916. MILAN, GALLERIA CIVICA D'ARTE MODERNA

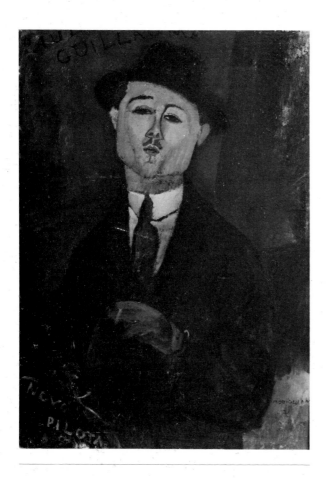

Paul Guillaume was a successful dealer who was handling Modigliani's work in 1915 and 1916, and was again in touch with him in 1918. A touching, somewhat cruel photograph (Fig. 7) shows a vigorous, tight-suited Guillaume leading a broken-down Modigliani along the Promenade at Nice in that year. Modigliani painted at least three canvases of Guillaume. His broad face did not lend itself to Modigliani's characteristic elongation, but the painter also had an opposite type of exaggeration for use in portraying the round-faced, like Diego Rivera, Oscar Miestchaninoff or Moïse Kisling. Such is his skill that we hardly notice the transition from one to the other. In all three paintings of Guillaume Modigliani stresses his worldly elegance, especially in the one lettered *NOVO PILOTA* (Fig. 25), where the dealer holds a cigarette in his gloved hand, and seems to be in the act of releasing smoke from the tiny mouth with which Modigliani, as usual, has endowed him. There is nothing in any of the portraits to suggest that the painter liked his subject — quite the contrary. All show a thinly veiled irony, bordering on contempt.

Fig. 25
Paul Guillaume
OIL ON CANVAS, 105 × 75 CM. 1916. PARIS, MUSÉE NATIONAL D'ART MODERNE

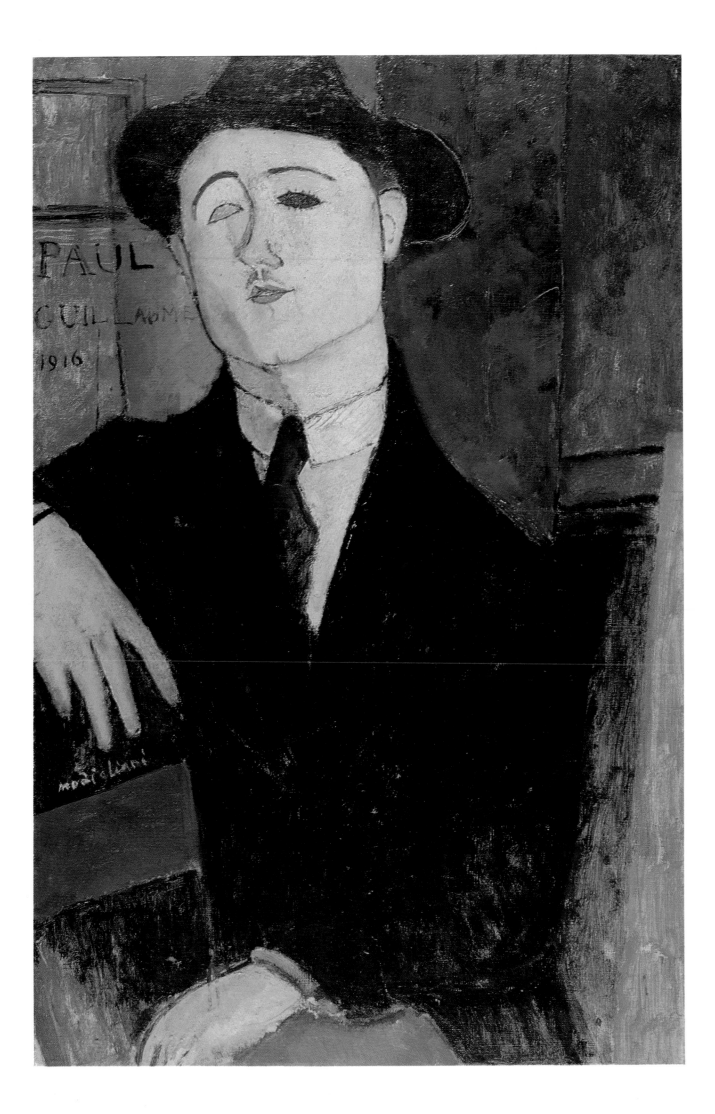

Juan Gris

OIL ON CANVAS, 55.5 × 38 CM. 1915. NEW YORK, THE METROPOLITAN MUSEUM OF ART

Among the most interesting of Modigliani's works are the group of paintings in which he represented other artists in Paris, most if not all of them immigrants like himself. They include some who have achieved fame, like Gris or Soutine, others who are little known like Miestchaninoff. Modigliani painted one, slight portrait of Picasso, but his portrait of Juan Gris is one of his most striking images. Like the portrait of Celso Lagar (Plate 20), it breaks through the devices of his current style to achieve an intense study of, and rapport with, another human being. This is rare in Modigliani, and is more likely to occur in his male portraits. The large feminine eyes, open and direct to a quite unusual degree, hold the attention away from the fleshy, epicene character of the face and neck.

The portrait of another painter who was close to Modigliani, Moïse Kisling (Fig. 26), is cast in a more ordinary mould. But here too, the face, if more perfunctorily painted, is open and candid, as if the painter felt thoroughly at home with the sitter. The effeminate character of the portrait of Gris does not correspond with his known image in other respects, and hints at some clash between the two men.

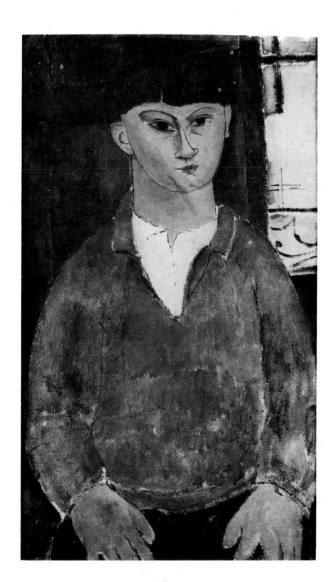

Fig. 26
Moïse Kisling
OIL ON CANVAS, 81 × 46 CM. 1916. PARIS, MUSÉE NATIONAL D'ART
MODERNE

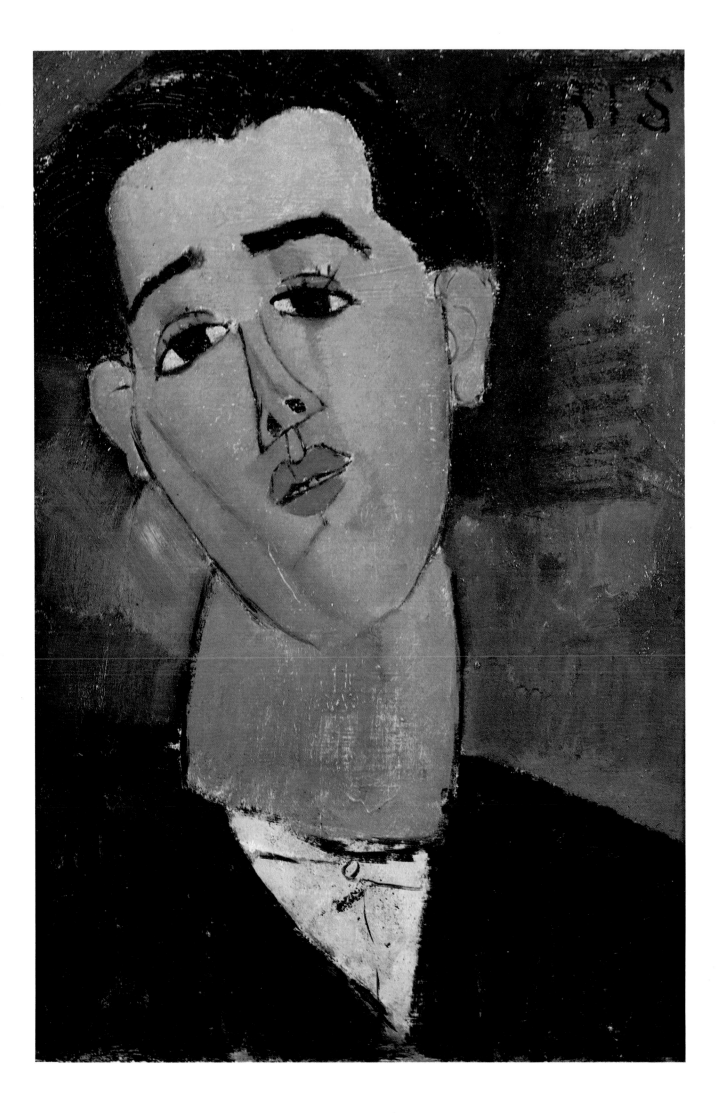

Chaim Soutine Seated at a Table

OIL ON CANVAS, 92 × 60 CM. 1916–17. WASHINGTON, D.C., NATIONAL GALLERY OF ART

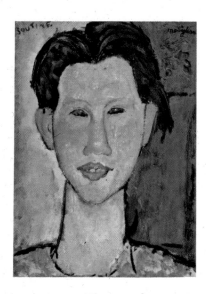

Fig. 27
Chaim Soutine
OIL ON CANVAS, 38 × 28 CM. 1915. STUTTGART, STAATSGALERIE

Among the group of immigrant artists with whom Modigliani associated, none was poorer or odder than the Lithuanian Jew, Chaim Soutine. Yet the highly educated Modigliani evidently felt a great bond with him, and he painted several very careful portraits of Soutine (see also Fig. 27). Modigliani did not spare the grossness of Soutine's features (see Fig. 8), putting aside his usual preference for a tiny mouth and thin nose. It is at this time that the influence of Cézanne can increasingly be seen in Modigliani's work. In its solid, frontal clumsiness, the large head seeming to tower over the rather slight body, the portrait recalls several of Cézanne's early portraits.

Regrettably, no portrait of Modigliani by Soutine is known. Stylistically, the two artists were far apart, for Soutine's hectic brushwork never admitted such a thing as a line, while Modigliani's whole art was based on drawing. Yet there is a still more basic quality that unites the two men. Both wished to interpret their unhappy experiences of society to themselves, and draw their sting by their painting, which provided them with a means to master certain aspects of life that obsessed them, and with which they could never come to terms in a more direct way.

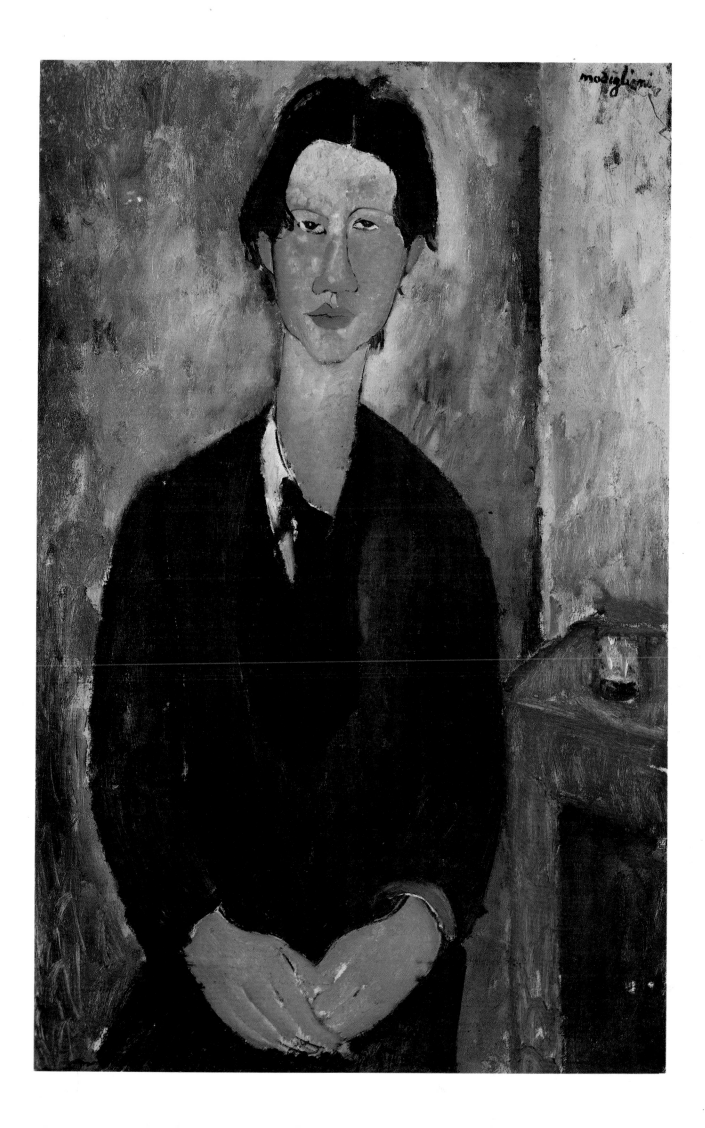

Seated Nude

OIL ON CANVAS, 92 × 60 CM. 1916. LONDON, COURTAULD INSTITUTE GALLERIES

Perhaps the most beautiful of all Modigliani's nudes, it is one of the earliest. It does not yet betray the over-fluency of line that leads the eye to slip all too easily over the profiles of the later nudes (Plate 39). Here, the most elegant and delicate profiles are conveyed by a somewhat broken line, sometimes heavy, more often light, in places made only by the boundaries between tones.

Of all the nudes, this seems the most likely to have been based on Modigliani's first companion Beatrice Hastings (Plate 18). Although the features are generalized and adapted to the needs of the composition, they are not incompatible with hers. If the hair is darker than the known portraits suggest, it might be because Modigliani wished to adapt it to the colours of the composition. There is a drawing of the nearly nude Beatrice (Fig. 22), which is the only certain record of Modigliani's relationship with her, and which in physical type, and psychological and sexual attitude, is easily reconcilable with the woman in Plate 26.

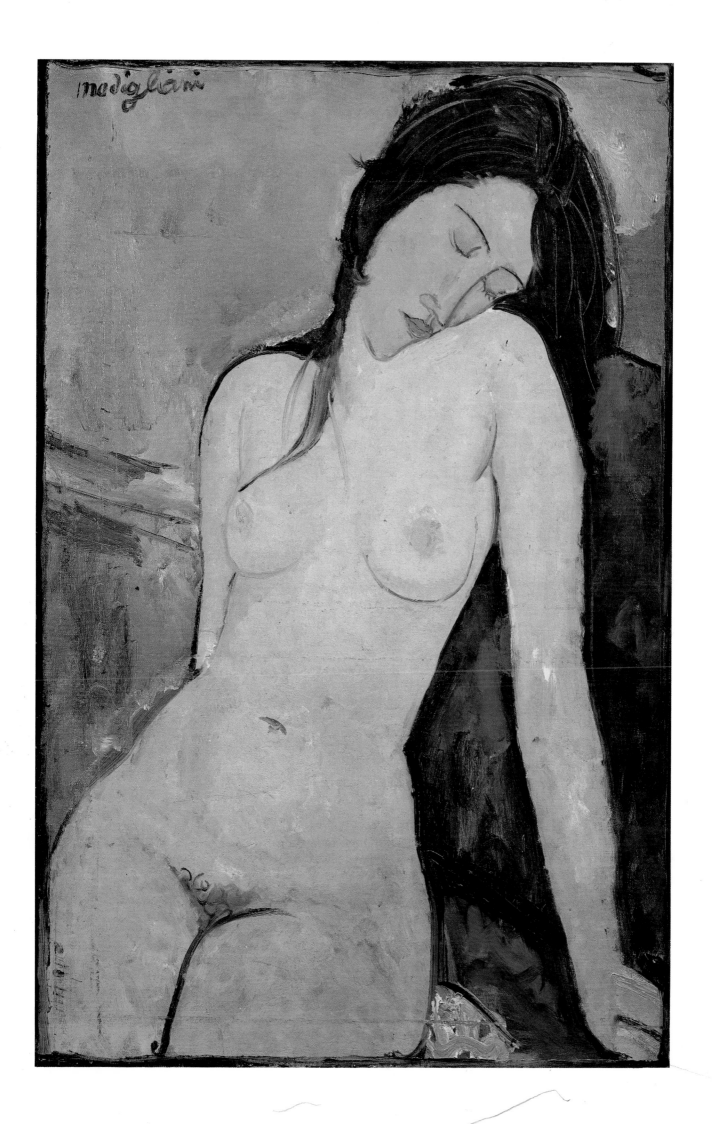

Seated Nude

OIL ON CANVAS, 81 × 65 CM. 1917. PRIVATE COLLECTION

It is difficult to account for such a substantial difference as exists between this seated nude and that of Plate 26, painted within about a year of each other. We may suppose that Plate 26 was painted under the influence of Beatrice Hastings, even if Beatrice was not the model. There is an elegance, and a sophisticated, pictorial invention about it. By contrast the plain pose, direct look and plump dumpy body of the girl in Plate 27 suggest a Courbet-like determination not to improve on the facts of nature. Nevertheless, the means Modigliani uses, the firm outlines, the warm even illumination and simplified modelling, have little to do with nineteenth-century realism. They belong rather to his own Italian tradition, the tradition not of the mannered fifteenth century but of the full, ripe human figure of the High Renaissance. The painting is as if a modern Raphael were painting his mistress. The identity of the model is not known. Moreover, it is not necessary to suppose, as some writers do, that Modigliani made a mistress, however fleetingly, of each of his models.

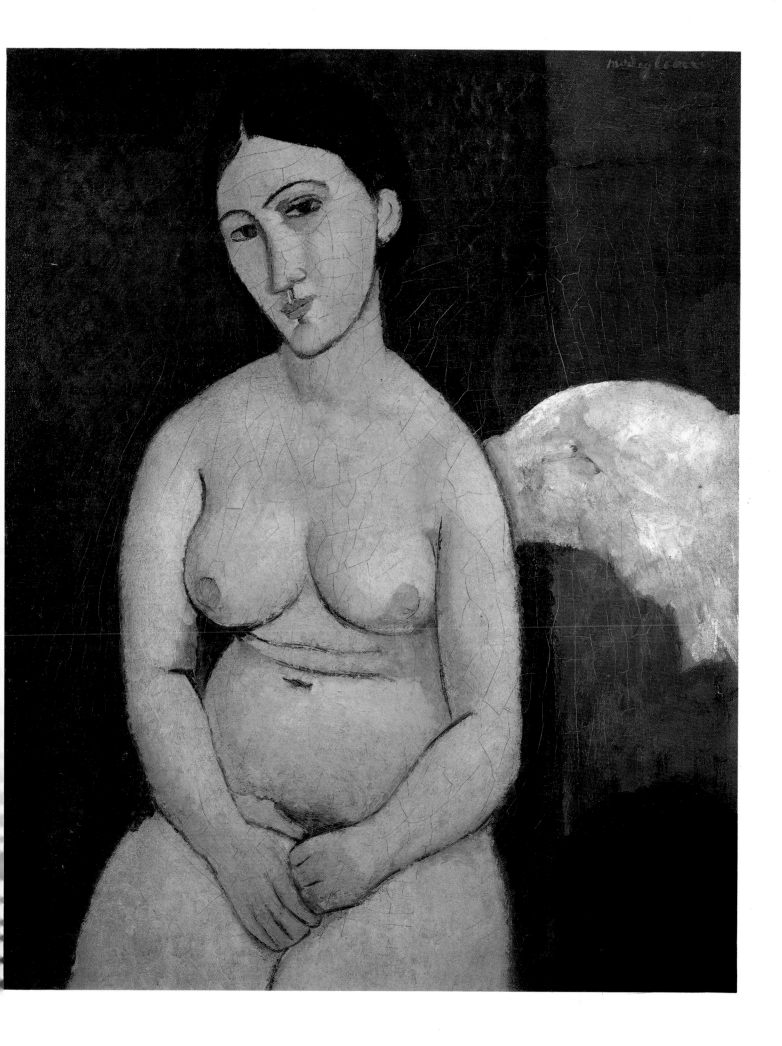

Monsieur Lepoutre

OIL ON CANVAS, 92 × 65 CM. 1916. PRIVATE COLLECTION

Modigliani's use of pale, chalky colours is mainly associated with his stay in the South of France in 1918, but occasionally is seen in earlier works. Here the pale colours are matched by an unusually tentative, broken drawing of the features, so that the image is a convincing parallel with the fading of old age. Modigliani's colour sense constantly reminds us of his Italian origin. He did not really have to submit to the influence of Cézanne or the light of the Midi in order to return to the dry ochreous colours of the south. If the colours of Plate 27 derive from the easel paintings of the High Renaissance, the colours of Plate 28 are equally clearly derived from fresco, even from external murals faded by exposure, or from the traditional colours applied to the façades of the buildings themselves.

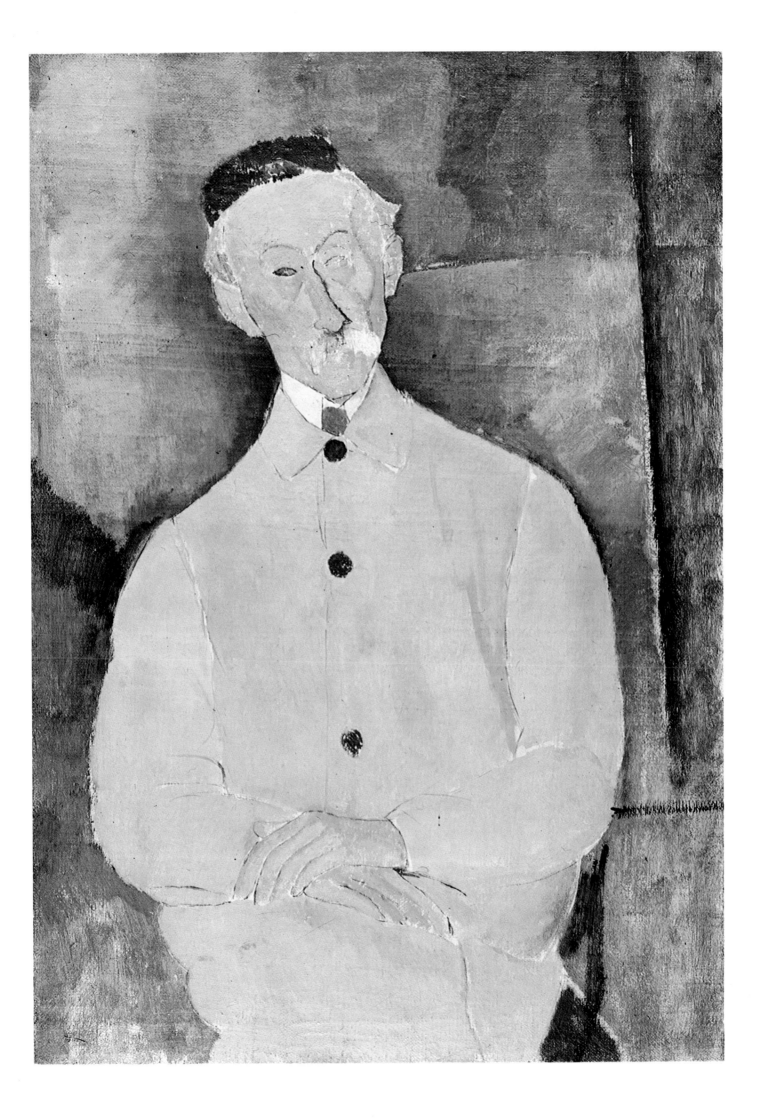

The Sculptor Lipchitz and his Wife

OIL ON CANVAS, 81 × 54 CM. 1916. THE ART INSTITUTE OF CHICAGO

Fig. 28
Max Jacob
PENCIL, 34.5 × 26.5 CM. 1916. PARIS, PRIVATE COLLECTION

Chaim Lipchitz (1891–1973) was yet another of the immigrant Jewish artists from the Baltic states, who formed part of Modigliani's circle in Paris. An ambitious and highly skilled sculptor — he made Modigliani's death mask after Kisling and another friend had failed to do so — Lipchitz went on to achieve success and settled in America after finding refuge there from the German occupation of France. Lipchitz was never intimate with Modigliani, and his portrait does not show the openness and intimacy of those of Soutine or Kisling. The double portrait, rare in Modigliani's work, was a commission from Lipchitz, who was beginning already to make some money, on the occasion of his marriage. Lipchitz, who was paying him by the hour, wanted him to spend more time in order to help him, but Modigliani refused to 'ruin' the painting.

The Lipchitz portrait displays a formality that is explained by its commissioned origin, as Modigliani usually selected his sitters himself. One may also see perhaps that neither husband nor wife was sympathetic to Modigliani. Mrs Lipchitz looks smug, and her husband places his hand on her shoulder with a proprietorial gesture. In short, Modigliani reacted badly to what he probably thought was the bourgeois character of the couple. Modigliani was not always flattering even to his friends, but the affectionate inscription on his drawing of Max Jacob (Fig. 28) is reflected by the tender delicacy of the drawing itself. Its advanced, 'cubist' character shows it to be a more careful production than the quick, perfunctory drawings for the Lipchitz portrait.

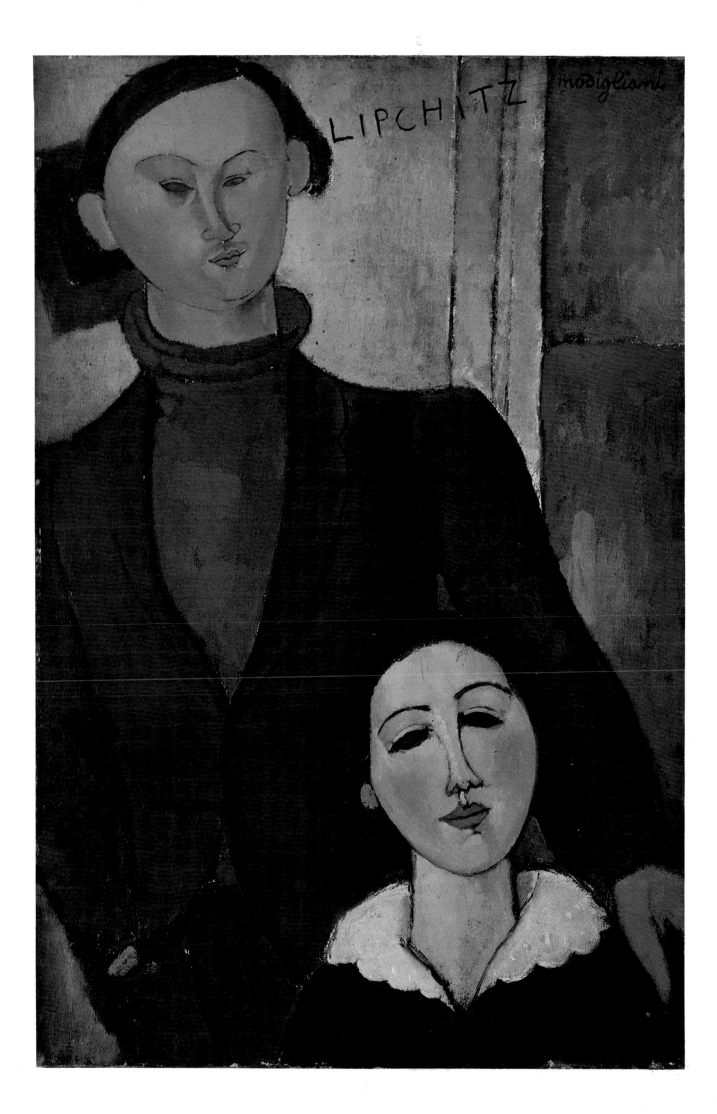

Portrait of a Girl (Victoria)

OIL ON CANVAS, 81 × 60 CM. C.1917. LONDON, TATE GALLERY

This portrait of a rather supercilious-looking girl, whose identity is not known, belongs to a period of balance in Modigliani's work. The tentative colouristic effects of 1914 (Plates 16 and 17), the modernistic efforts of 1915 and the formulas he used in that year and in 1916, were behind him. The more highly mannered style of 1918–19, with its characteristic elongations, was still to come. Thus the sitter confronts us with a poise that comes not only from her apparent character but from a straightforwardness with which Modigliani set her down on the canvas. But the lively appearance of her features still depends on the sharp surface drawing of the previous period, and if one compares the portrait with Fig. 29, for example, the sad, withdrawn character produced by Modigliani's later style is painfully apparent.

Fig. 29
Hanka Zborowska
PENCIL, 38 × 24 CM. 1917. PARIS, PRIVATE COLLECTION

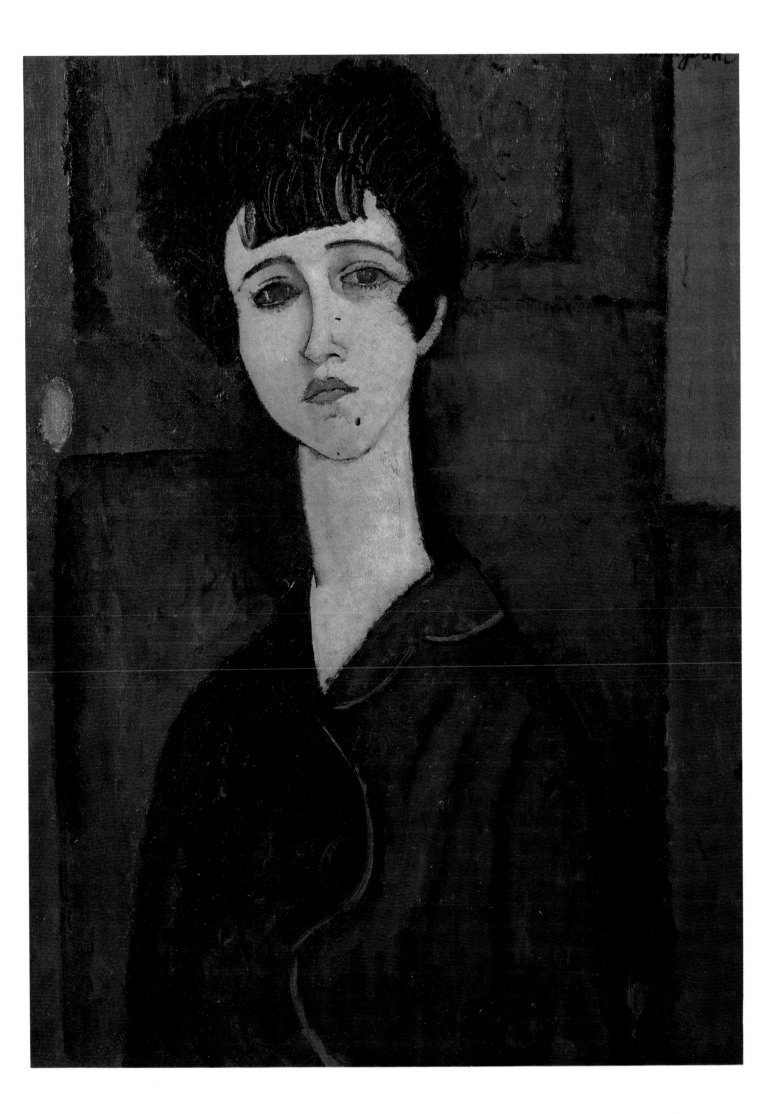

Madame Zborowska on a Sofa

OIL ON CANVAS, 130 × 81 CM. 1917. NEW YORK, MUSEUM OF MODERN ART

This is the first plate of this book in which the final 'type' of Modigliani is clearly seen, the type with which he is still most usually identified. As the book shows, there is much more variety in Modigliani's work than this. The well-recognized stereotype of Modigliani belongs mainly to the work of 1917 to 1919 only, principally to the portraits. The type is distinguished by pronounced mannerism, not only in the features of the face where we have already seen a 'formula' at work, but in the whole composition. Here both the features of the face and the pose of the body conform to the strong diagonal. The features are drawn out along the axis of this diagonal but, keeping their horizontality, can be 'read' as if their owner was looking at us full-face. They are rendered less calligraphically than before, but with an even more pronounced line and a ruthless elongation. A more naturalistic and casually posed drawing of Hanka (Fig. 29) shows how far Modigliani's mannerism has gone in her case.

All Modigliani's exaggerations are based on ordinary observation, and for that reason are accepted easily. The 'simultaneous representation' used by the Cubists and Futurists was not for him, and he did not live to be aware of the metamorphism of the Surrealists. Nevertheless, in his easy-going way, he expanded the possibilities of what a painter could do to his subject within the limits of acceptability.

Anna or Hanka Zborowska was the wife of Leopold Zborowski (Plate 35), who was a friend, supporter and dealer for Modigliani in the last troubled phase of his life. She must have played an important role in Modigliani's affairs, but the portrait does not testify to affection, and according to some accounts, Mme Zborowska was unpopular among Modigliani's friends.

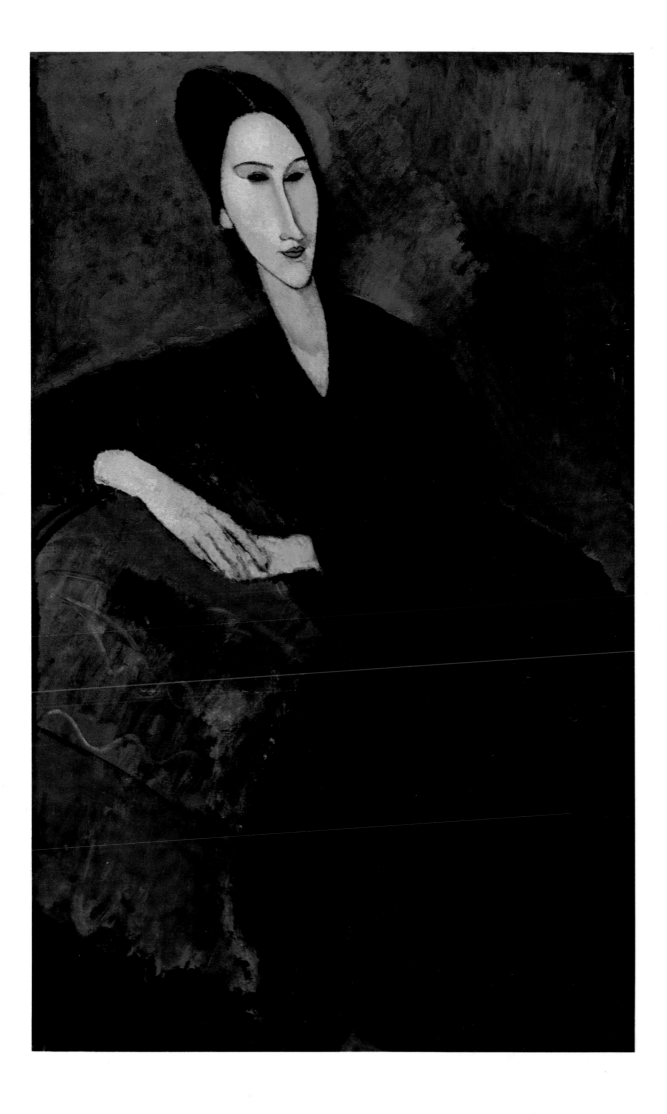

Reclining Nude with Blue Cushion

OIL ON CANVAS, 60 × 92 CM. 1917. NEW YORK, COLLECTION OF MR NATHAN CUMMINGS

Even if Modigliani's life had been orderly and meticulously chronicled, his paintings of nudes would have been the subject of speculation. There exists in twentieth-century art a thick undergrowth of erotic imagery, from which occasionally a painting may emerge by its own merits to the status of an independent work of art, but very rarely reaches the rank of the genuinely innovative masterpiece of modern art. Modigliani's nudes are certainly works of art. Some of them are masterpieces, but without losing any of their memorable erotic content. To acknowledge this is not to acquiesce in the assumption that Modigliani's nudes are only a visual record of sexual adventures. Despite everything, Modigliani was essentially a painter to the core and his ability to convey erotic feeling professionally, not anecdotally, should not be impugned. His nudes are erotic as Titian's or Renoir's are erotic; they are not pornographic.

Certainly the faces of Modigliani's models are individual, and their expressions contribute to the eroticism. Here the painter has rather

unkindly given the model not only a shiny nose but a double chin, although her body is otherwise slim. Such features are seldom found in Modigliani's actual portraits. The slimness of the body contributes to the pronounced diagonal of the composition, reinforced by the rather arbitrary way in which the right arm cradles the head while the left arm is kept out of sight. This is the pose of the Giorgione *Venus* (Fig. 30), one of the most famous and beautiful of all depictions of the nude, although Giorgione allows the right arm to contribute to the erotic content in a way that Modigliani did not care, or perhaps dare, to show.

Fig. 30
GIORGIONE
Sleeping Venus

OIL ON CANVAS, 108 × 175 CM. DRESDEN, GEMÄLDEGALERIE

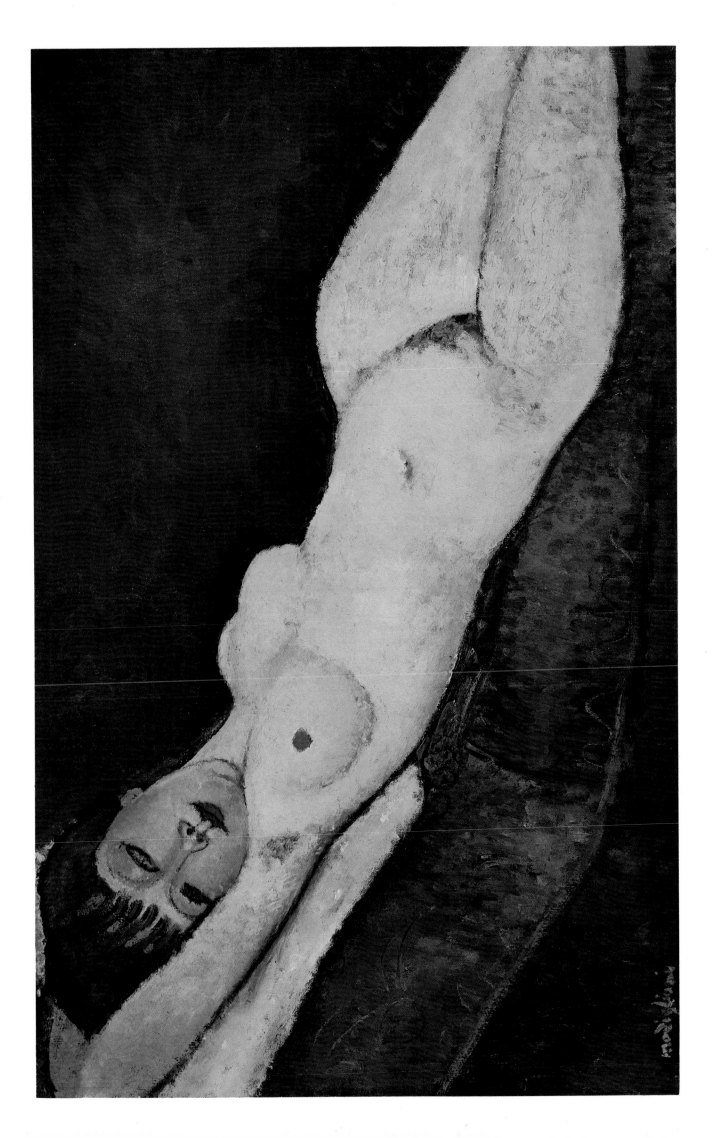

Reclining Nude, Raised on her Right Arm

OIL ON CANVAS, 65 × 100 CM. 1917. WASHINGTON, D.C., NATIONAL GALLERY OF ART

Modigliani's nudes are never deeply concerned with detailed naturalistic observation, but they vary in the observed detail they contain. Plate 27 has already provided an example of the general truth to nature Modigliani achieved while working within a very long tradition. In Plate 33 we recognize a more careful observation of the way the heavy breasts fall and the characteristic stretching and cooling of the tone of their skin. Yet the legs are hardly rendered as solid bodies and narrow off unsatisfactorily into the corner of the canvas. It is a device that Modigliani often took refuge in.

Looking at such an image as this, it is easy to recall that Modigliani's first exhibition at the Galerie Berthe Weill in December 1917 was closed by the police who were obviously responding to the erotic content of the nudes. As already noted, this erotic effect is certainly connected with the portrayal of the models as individual women, and the model in this case is one of the most individual and appealing.

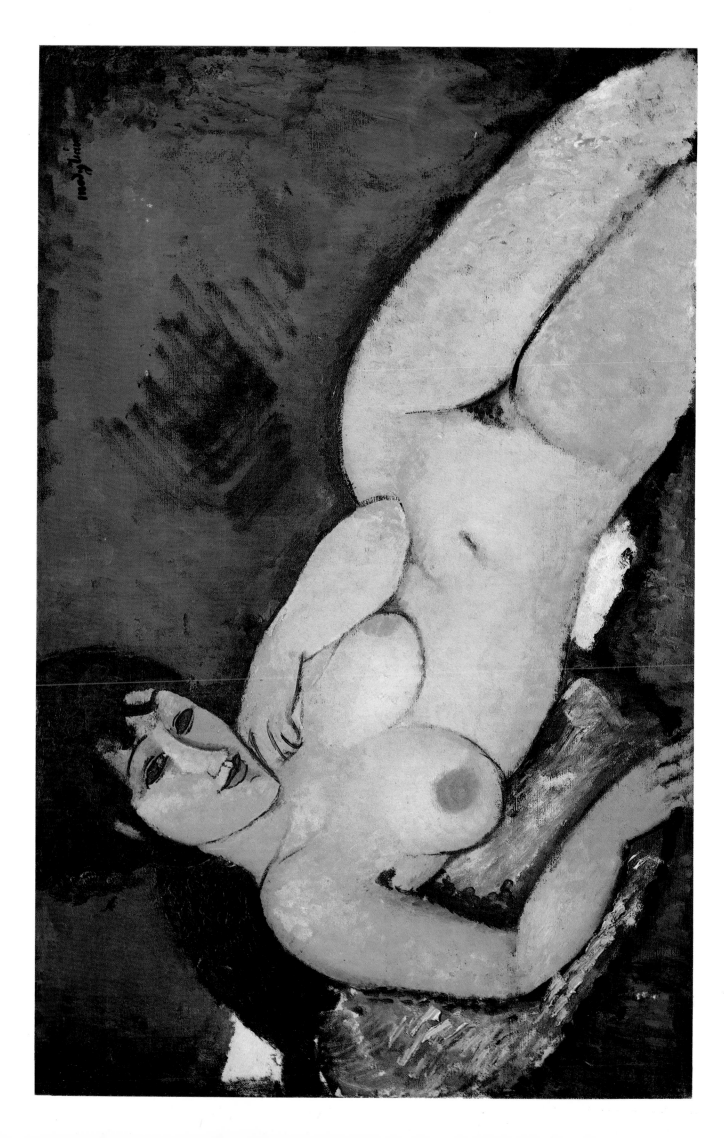

Portrait of a Girl

OIL ON CANVAS, 46 × 29 CM. 1917–18. PRIVATE COLLECTION

This charming portrait has sometimes been identified as that of Jeanne Hébuterne, who, however, had blue eyes. Whoever it represents, it is an unusually open and candid portrayal of the sitter, who looks out with trustful eyes, which are neither blank nor half obscured, nor yet staring or knowing like those of some of Modigliani's nude models. The painting of the features themselves, while they conform to Modigliani's norm in their elongation, displays less of his characteristic style than usual — the end of the nose and the perfect cupid's-bow mouth are almost conventional in their drawing. By comparing this portrait with Plate 30, one may see how Modigliani was then changing so rapidly. Contrasted with the abrasive smartness of *Victoria*, Plate 34 is soft and almost irresolute. Perhaps this softness is due in part to personal factors, if the girl portrayed was for that time the object of Modigliani's affections. But in so far as Plate 34 represents a phase of classicism, before the final mannerist phase of the work, one should admit that this classicism was born out of lassitude and cessation of effort, more than out of maturity and balance.

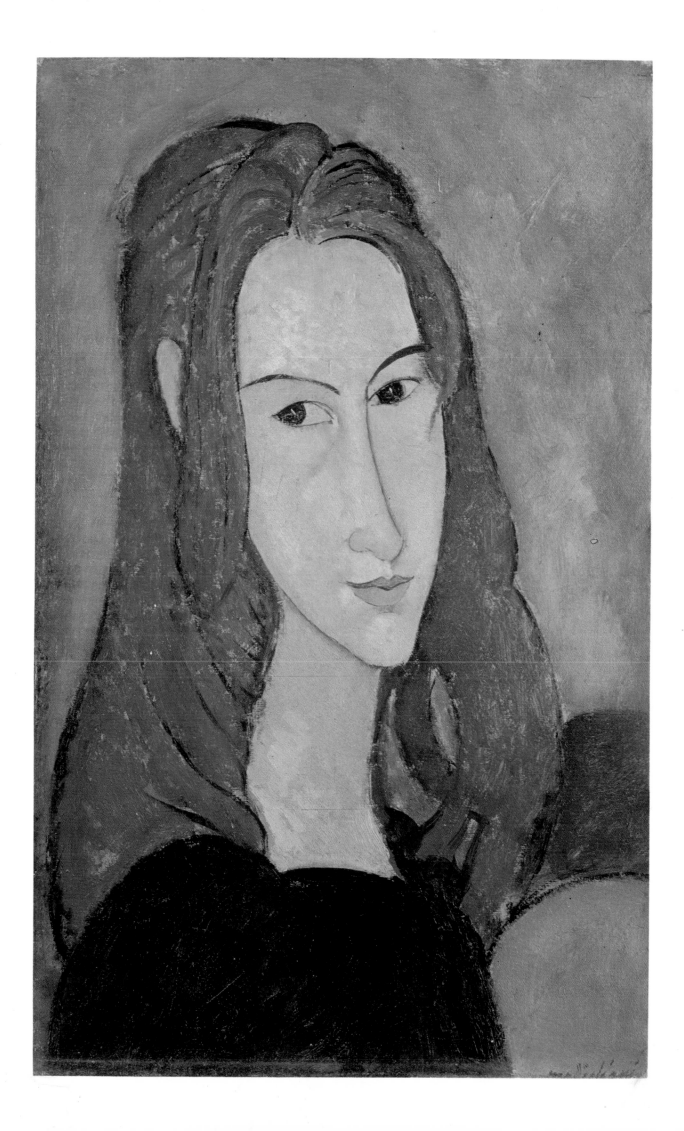

Leopold Zborowski

OIL ON CANVAS, 46 × 27 CM. 1918. PRIVATE COLLECTION

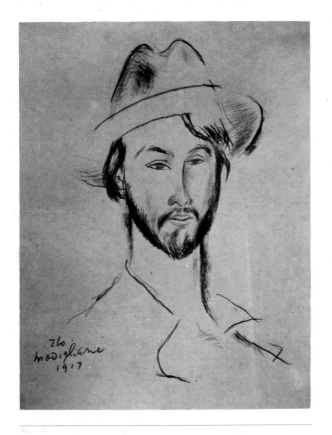

Leopold Zborowski was probably known to Modigliani for some years before he became the painter's dealer and, finally, the practical mentor who tried unsuccessfully to keep him on the straight and narrow. The relationship between the two men was close enough in 1915 for Modigliani to draw Zborowski naked in the guise of St. John the Baptist. The several portrait paintings and drawings of him are sympathetic, even when Modigliani represented him, as he did Paul Guillaume twice, in a dealer's 'uniform' of smart suit and striking tie, as he is seen in Fig. 8. But Plate 35 can be taken as the more characteristic appearance of the man Modigliani and other *peintres maudits* knew. This is supported by the drawing of him (Fig. 31), in which he looks untidy.

As well as being sympathetic, this portrait is also exceptionally well painted. Here Modigliani's 'formula' appears at its most spontaneous and genuine, the features being perfectly integrated into the modelling of the head, and painted with exceptional delicacy. The hair and especially the beard and moustache are set down freely and with no corrections.

Fig. 31
Leopold Zborowski
BLUE PENCIL, 28.5 × 22.5 CM. 1917. TROYES, MUSÉE D'ART MODERNE

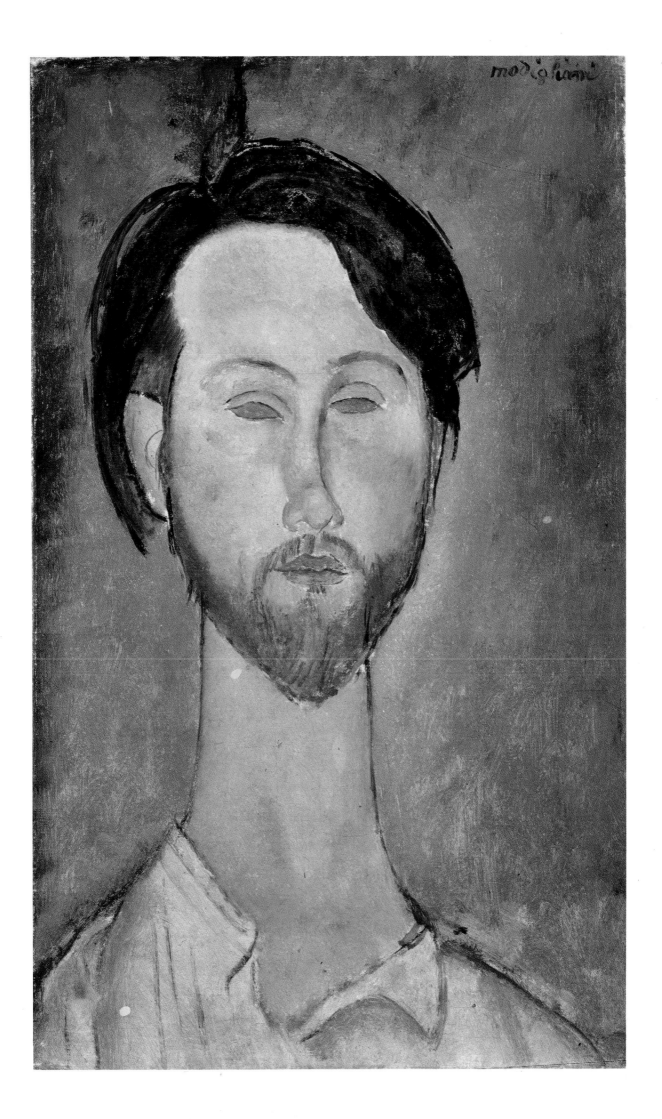

Reclining Nude

OIL ON CANVAS, 60 × 92 CM. 1917. STUTTGART, STAATSGALERIE

This admirable painting must vie for a very high position in a hierarchy of Modigliani's nudes. Although abundantly sensual, it is also successfully generalized. The face is not particularized and portrait-like, as in Plate 33, but is reduced to essentials. In this context Modigliani judged the essentials to be the eyes, which alone seem to collect together and transmit to the viewer (and surely the painting was intended for an audience of one) the concentrated essence of feminine sexuality. The body is, for Modigliani, exceptionally well articulated into the principal masses — comparison with Plate 32, for instance, shows how well defined are the angle and lie of the breasts, the rib-cage, haunches, stomach and thighs. The cut-off point of the legs, well above the knees, avoids the weakness so clearly seen in Plates 33 and 39.

By this picture, if no other of his nudes, Modigliani invites comparison with the grand tradition of the nude as exemplified by Giorgione, Titian, Velazquez, Goya or Manet. It is perhaps with the frank come-hither sexuality of Goya's *La Maja Desnuda* (Fig. 32), with its discreet balance between naturalism and elegance, that comparison can best be made in this case.

Fig. 32
GOYA
La Maja Desnuda

OIL ON CANVAS, 97 × 190 CM. C.1798–1805. MADRID, MUSEO DEL PRADO

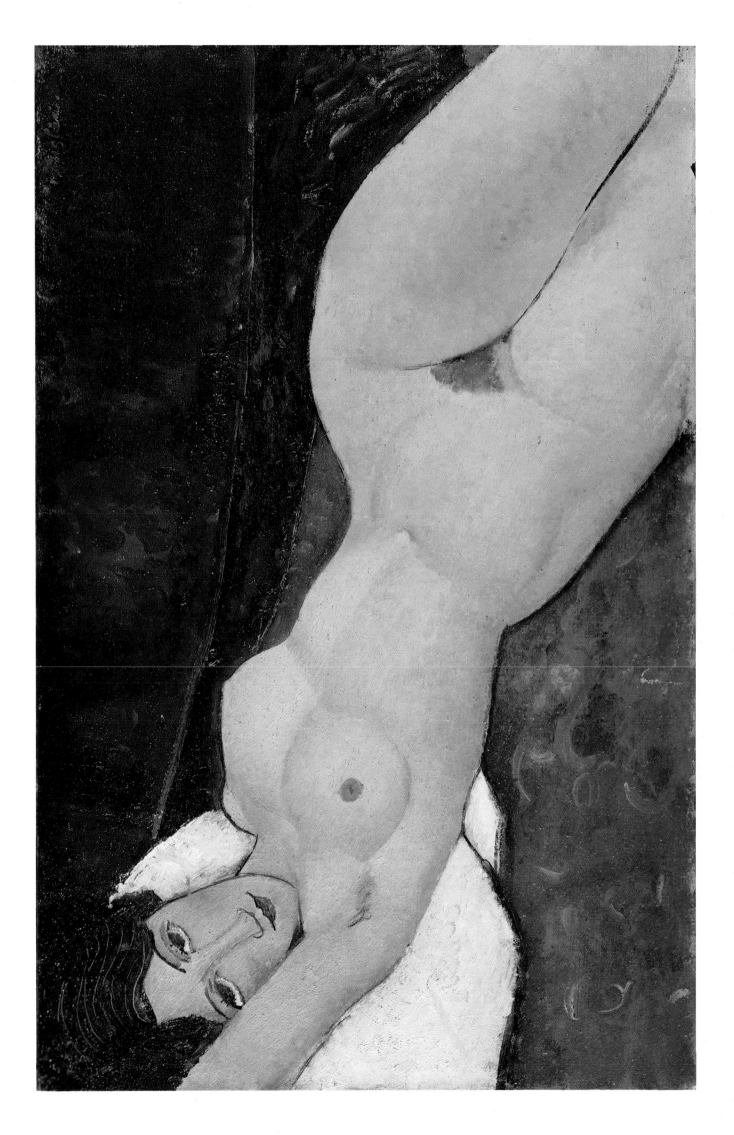

Nude Looking over her Right Shoulder

OIL ON CANVAS, 89 × 146 CM. 1917. PRIVATE COLLECTION

In the scale of erotic values, the nude from behind has a special place. Boucher used it to devastating effect, but the most famous image of the nude female back is doubtless Velazquez's *Toilet of Venus* (Fig. 33), where the eroticism is subsumed in the breathtaking beauty of the figure. However it is certainly not of such courtly painters, but rather of the Dutch school or of Courbet that one thinks in connection with this rather beefy nude. Although Modigliani's fluency and fundamental artistry produce a striking image, which is not without grace, when he decides, as here, to portray the whole figure his occasional weakness of drawing cannot be concealed. It is evident in the lower legs and especially the ankles and feet, and such weaknesses are mercilessly highlighted by comparison with Velazquez.

The apparent exaggeration of hips and thighs may be intended to heighten the erotic effect already conveyed by the pose. Like Plate 33, though not so much, the face is personalized, the glance seemingly off-guard and warning off, which does nothing to diminish the sexuality implicit in the painting. These aspects add up to one of the most obviously erotic of Modigliani's nudes, but this result is achieved at the expense of the generalization and the classicism that make Plate 36 one of the finest nudes of modern times. The parts of the body in Plate 37 are sharply defined, but lack the balance and unity that together make for a perfectly composed painting.

Fig. 33
VELAZQUEZ
The Toilet of Venus

OIL ON CANVAS, 122 × 177 CM. C.1645-8. LONDON. NATIONAL GALLERY

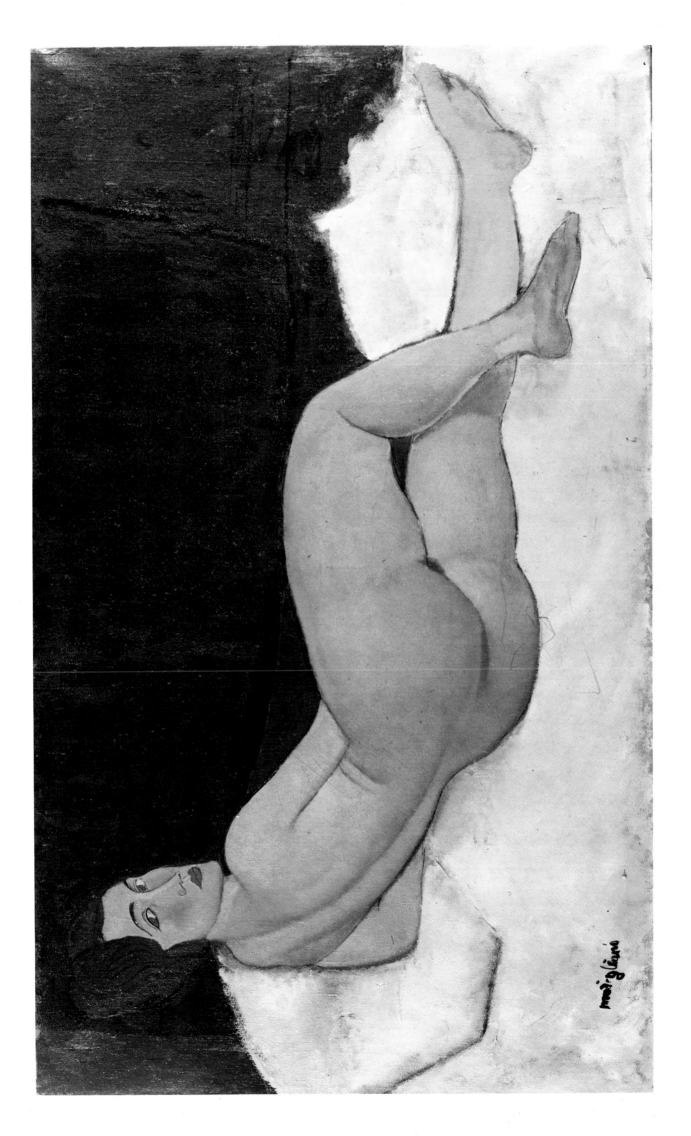

Reclining Nude (Le Grand Nu)

OIL ON CANVAS, 72.4 × 116.5 CM. C.1919. NEW YORK, MUSEUM OF MODERN ART

This, the largest of Modigliani's nudes, is also the most pictorially decorative. Showing less interest than usual in the erotic content, the painter has stretched out the torso to an unnatural degree. Under the torso is a dark passage in the rugs or drapes on which the model lies, so that the torso appears, curiously, like a bridge between the upper and the lower parts of the figure, which are of natural proportions. Unusually, the head is in profile, and the hands are shown. A rather dramatic lighting from the right, lighting up the face as if from below, contributes another unusual feature to this exceptional work.

In considering the exaggeration in Modigliani's nudes, it is interesting to bear in mind that they are based on instinctive distortions similar to those used in his portraits. Their aim too is similar — to bring to the spectator an acute sense of presence by reshaping the familiar form we know into a more vivid presentment. In the portraits, it is a presentment of personality, in the nudes it is, inevitably, a presentment of sexuality. The distortions are carefully, if intuitively, calculated but sometimes they exceed the limits of what is effective. Just as an over-long neck may turn a portrait into an iconic image, the over-long torso in Plate 38 has turned a sexual into a decorative figure.

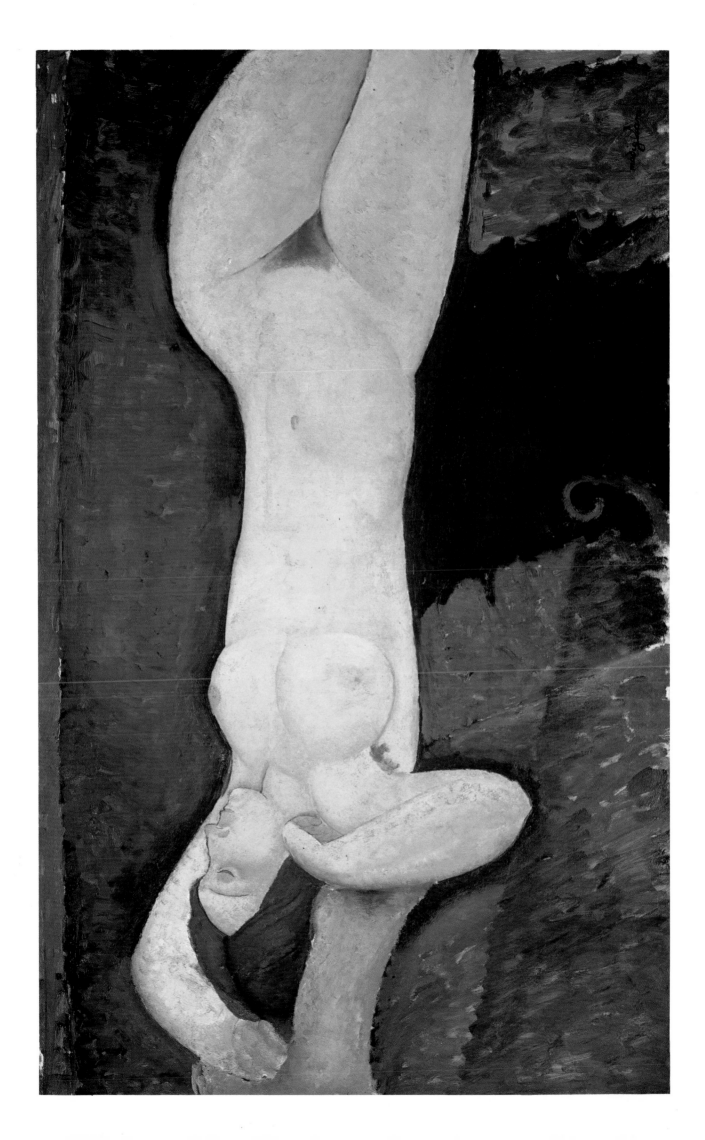

Nude with Necklace, her Eyes Closed

OIL ON CANVAS, 73 × 116 CM. 1917. NEW YORK, THE SOLOMON R. GUGGENHEIM MUSEUM

Compared with Plate 38, this nude conforms to the more usual type, and tends towards the smooth, unstructured variety with flowing profiles. The features of the face are very simply drawn, and, as in Plate 38, the eyes are closed. This damps down considerably the erotic aspect of the painting, and recalls the convention in nude photography that the model's eyes must not look at the camera. We may remember again that Modigliani's show at Berthe Weill's was closed by the police because the nudes were considered pornographic. It is possible that Modigliani tried on some occasions to counter this accusation, though he continued to show the pubic hair, which was even more inadmissible.

In the present state of knowledge of the dating of Modigliani's works, it is impossible to say whether any of the nudes were painted after the exhibition or not. Most of them are conventionally grouped in 1917, the year the exhibition took place, but there are too many for this to be reasonable. It is likely, however, that they were painted rapidly. Having found a successful formula, Modigliani seems to have been tempted to repeat it frequently, only occasionally rising above it to produce a work of exceptional quality. Questions arise as to his method — how much is each painting studied directly from the model? Were different models in fact employed? Did Modigliani make use of photographs in any way? It does not seem that any of these questions can be definitely answered.

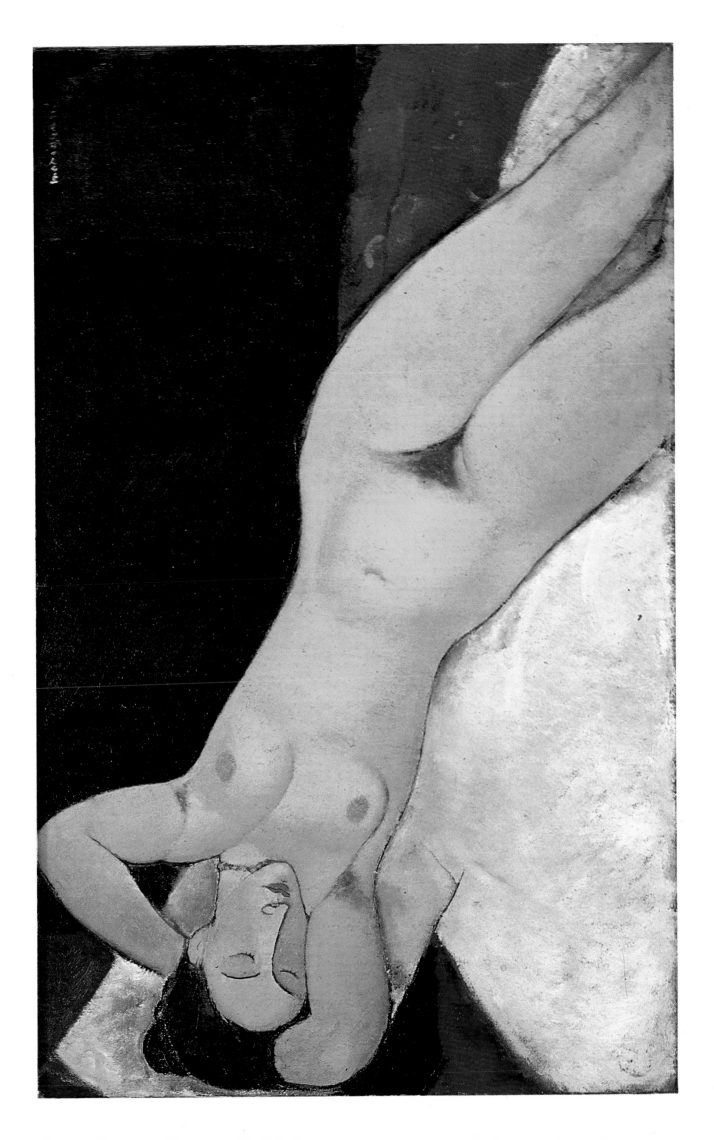

The Young Apprentice

OIL ON CANVAS, 100 × 65 CM. 1918. NEW YORK, THE SOLOMON R. GUGGENHEIM MUSEUM

Modigliani's stay in the south of France, where he went in the spring of 1918, rapidly affected his art. There is an influx of dry, bleached, southern colours, and a renewed attention to the work of Cézanne (Fig. 34). An almost new type of picture, too, makes its appearance, the decorative figure-piece that is neither portrait nor nude. Leopold Zborowski, who organised the expedition to the south, evidently found local people to pose for Modigliani. The same model must have served for both Plates 40 and 41, although the pictures now bear different descriptions. Plate 40 is among the most monumental of Modigliani's paintings, calm and weighty with its consciousness of the boy's heaviness and patient pose. The features of the face, often hitherto of such vital interest, are now rendered inexpressively, like still life; but they are beautifully painted. This group of paintings represents a brief period of ripeness in Modigliani's work, which can be more easily seen where he had no involvements with the sitter. Ironically, it is in Cézanne's portraits of his patient wife, whom he was evidently in the habit of regarding as part of the furniture, that the same calm objective stillness can best be appreciated.

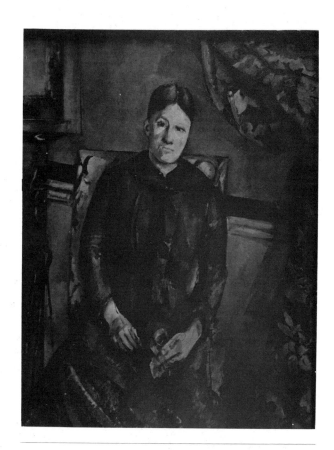

Fig. 34
CÉZANNE
Madame Cézanne in Red
OIL ON CANVAS, 116 × 89 CM. 1890–4. PARIS, PRIVATE COLLECTION

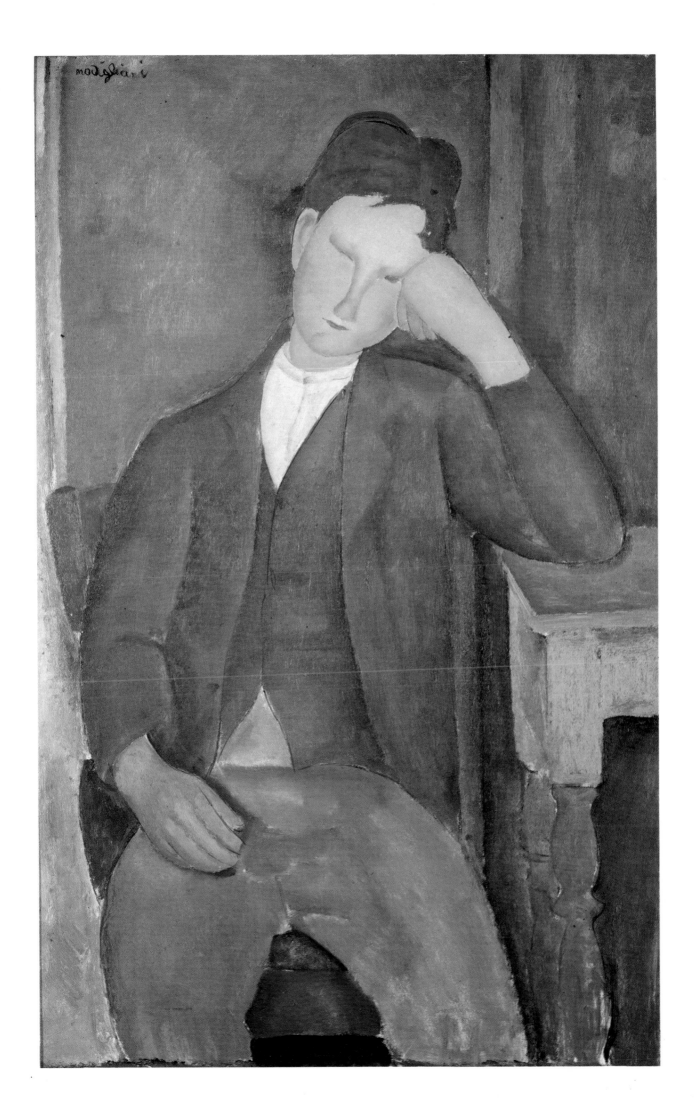

The Little Peasant

OIL ON CANVAS, 100 × 65 CM. C.1918. LONDON, TATE GALLERY

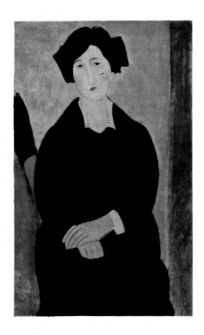

Fig. 35
The Italian Girl

OIL ON CANVAS, 100.2 × 67 CM. 1918. NEW YORK, THE METROPOLITAN
MUSEUM OF ART

Compared with its close counterpart, Plate 40, this painting carries more anecdotal detail — the hat, the tight waistcoat, the youth's excessively artless pose and expression. Yet it too is monumental and is in fact conceived more in the round, and modelled by light, than Plate 40. The picturesque details do not detract from this unity of mass. It is a measure of Modigliani's versatility — some might say his complaisance — that at the same period he was capable of conceiving a portrait entirely in profiles if the subject seemed to require it. Such a subject was the black-haired Italian girl (Fig. 35), her black dress relieved only by white collar and cuffs. All this black is enclosed in outlines almost as simplified as those in *La Belle Epicière* (Plate 42), but played off against each other in a more sophisticated manner. The profile treatment of the body has seemed to dictate to Modigliani a more linear treatment of the face. The delicacy of the lines and tones of the face and its background, contrasted with the large black masses and set with a sure sense of interval against the green strip on the right — all this evokes an echo of Japanese art.

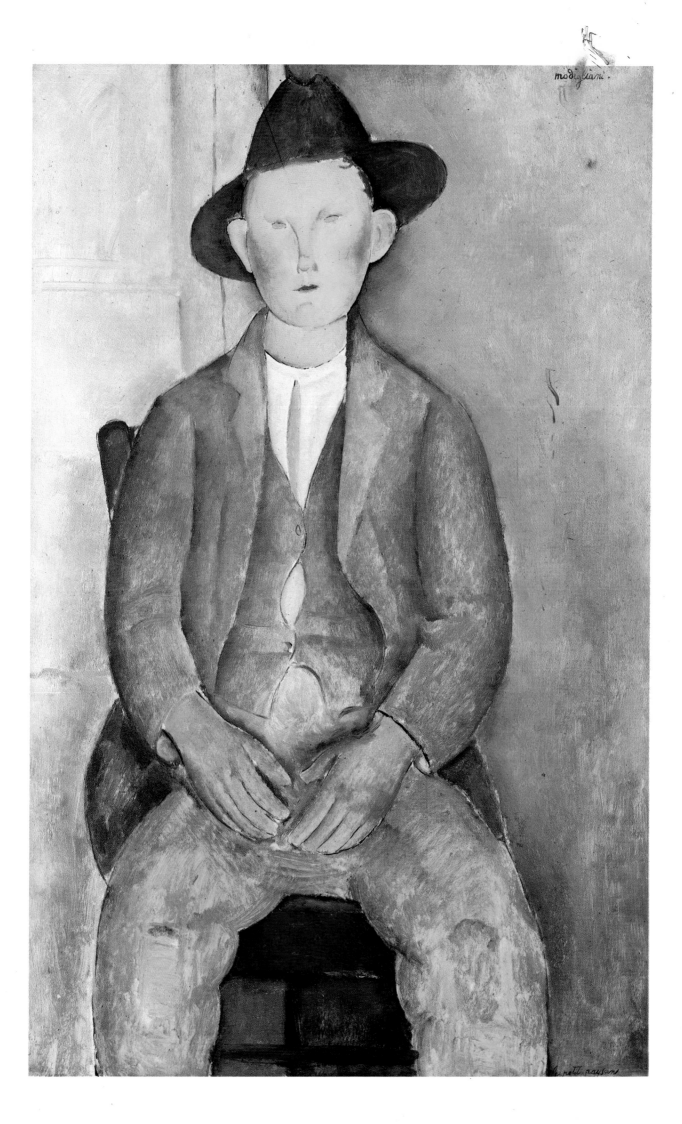

La Belle Epicière

OIL ON CANVAS, 100 × 65 CM. 1918. PRIVATE COLLECTION

This rather ironically titled work represents the extreme of impersonality in Modigliani's painting. He never painted still lives, and the props and backgrounds in his portraits are usually insignificant, but he has treated this young woman as a still life. He has gone further, for he has simplified her shapes into a series of ovals — the head, the shoulders and arms, the white apron. In the background, where Modigliani has written the first four letters of the shop name, *EPIC(erie)*, we see one of his rare attempts to paint natural phenomena. In this case it is merely the trunks of three trees, one nearby and two against the wall of the shop. They show no foliage, and are painted with an austerity to rival the most severe old Italian fresco.

The very few surviving landscapes by Modigliani are associated with his stay in the south of France between April 1918 and May 1919, and especially with the months he spent in Cagnes early in 1919. Soutine was also at Cagnes, and his passion for landscape may have affected Modigliani. However, the *Tree and Houses* (Fig. 36) is also austere and Italian, and totally uninfluenced by Soutine's wildly expressionist manner of painting.

Fig. 36
Tree and Houses

OIL ON CANVAS, 55 × 46 CM. 1919. PRIVATE COLLECTION

Little Girl in Blue

OIL ON CANVAS, 116 × 73 CM. 1918. PRIVATE COLLECTION

Like Plates 40 and 41, this represents a local, non-professional model. But compared with them, the subject is here depicted with a greater degree of personality. Perhaps the child's nascent femininity interested Modigliani — at any rate, he does not flinch from her steady gaze. Unusually, the child is shown in a very clear spatial environment; although Modigliani has not put in the vertical line of the corner, he has very exceptionally painted the floor and thus clearly shows that the figure is standing in the corner of a room. Another painting in which Modigliani does this is *The Young Chambermaid* (Fig. 37) in which the surroundings are even more detailed, but which lacks the special intensity of the *Little Girl in Blue.*

According to the Modigliani legend, 'in the corner' is where the painter would have liked to put this child. He had sent her out for some wine, and she had brought him instead lemonade. Some such dialogue between the two might explain the intensity of the gaze and Modigliani's evident concentration on painting the figure straight off at a single sitting.

Fig. 37
The Young Chambermaid
OIL ON CANVAS, 152 × 61 CM. 1918. BUFFALO, NEW YORK, ALBRIGHT-KNOX ART GALLERY

Seated Boy with Cap

OIL ON CANVAS, 100 × 65 CM. 1918. PRIVATE COLLECTION

Painted apparently from a different model from the one seen in Plates 40 and 41; his thin face and large ears are seen in at least one other painting of this period. Plate 44, although in the same category as those already described, shares something of the serpentine line and mannered composition of the very late paintings. Instead of sitting four-square, the boy sits hunched sideways against the trumpet-shaped chairback, his unseeing pale blue eyes gazing into vacancy. In such a manner did Modigliani paint Jeanne Hébuterne in some of his late portraits of her. The Mediterranean sense of fullness and stability that makes paintings like Plates 40, 41 and 43 such a high point, and also a relief, in Modigliani's work as a whole, is here replaced by his more customary unease. In fact, Modigliani's state of mind while staying in the south of France was more often uneasy and dissatisfied than it was stable. Despite his Italian origins, the brilliant light seems to have disturbed him and he desperately missed Paris and the company of his Bohemian friends. At the end of May 1919 he returned to Paris.

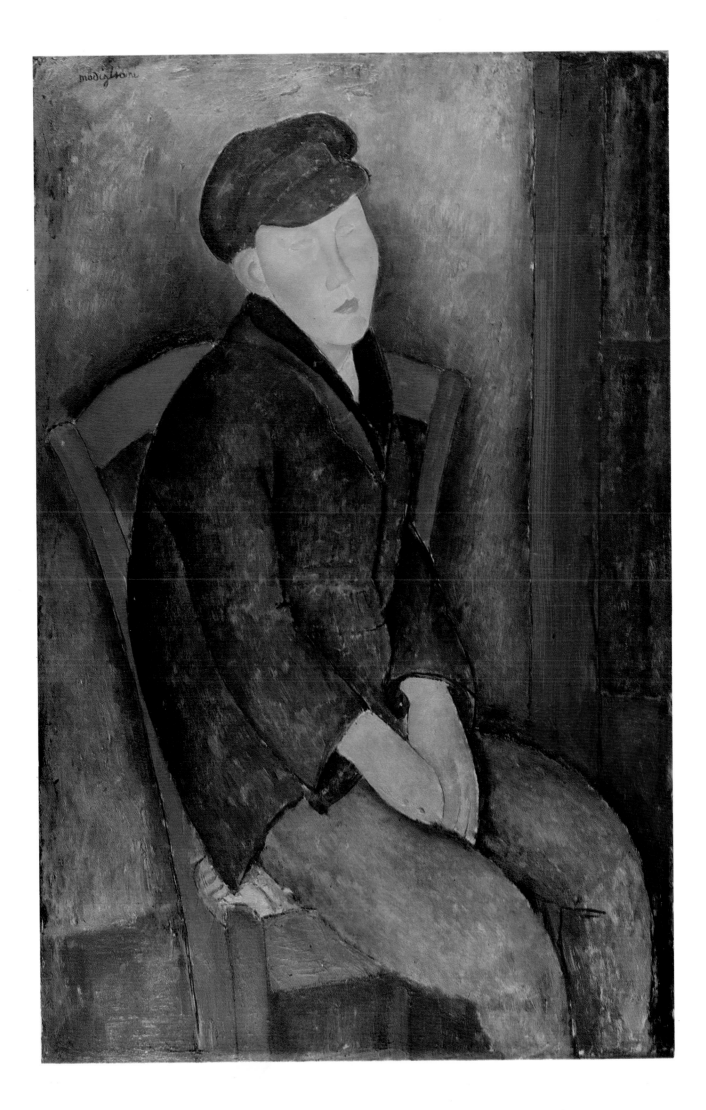

Girl in a White Chemise

OIL ON CANVAS, 73 × 50 CM. 1918. PRIVATE COLLECTION

Among the paintings done in the south of France are one or two nudes or semi-nudes such as this that lack the sexual intensity of the great series of nudes of 1917. In this example, there is hardly even any coyness in the pose and gesture of the girl-child whose petticoat slips down to reveal a small breast. She is in the tradition of the shepherdess or milkmaid as observed by the townsman; a decorative tradition active in the eighteenth and nineteenth centuries that had no social significance. As in the best of the southern paintings, she is painted with economy, simplicity, directness and absence of fuss, with that fresco-like appearance that constantly reminds one of the Italian in Modigliani. Paintings like this were included in the exhibition in London in 1919, organized by Osbert and Sacheverell Sitwell, and they contributed to the show's comparative success. After his death they were among the most popular of his works.

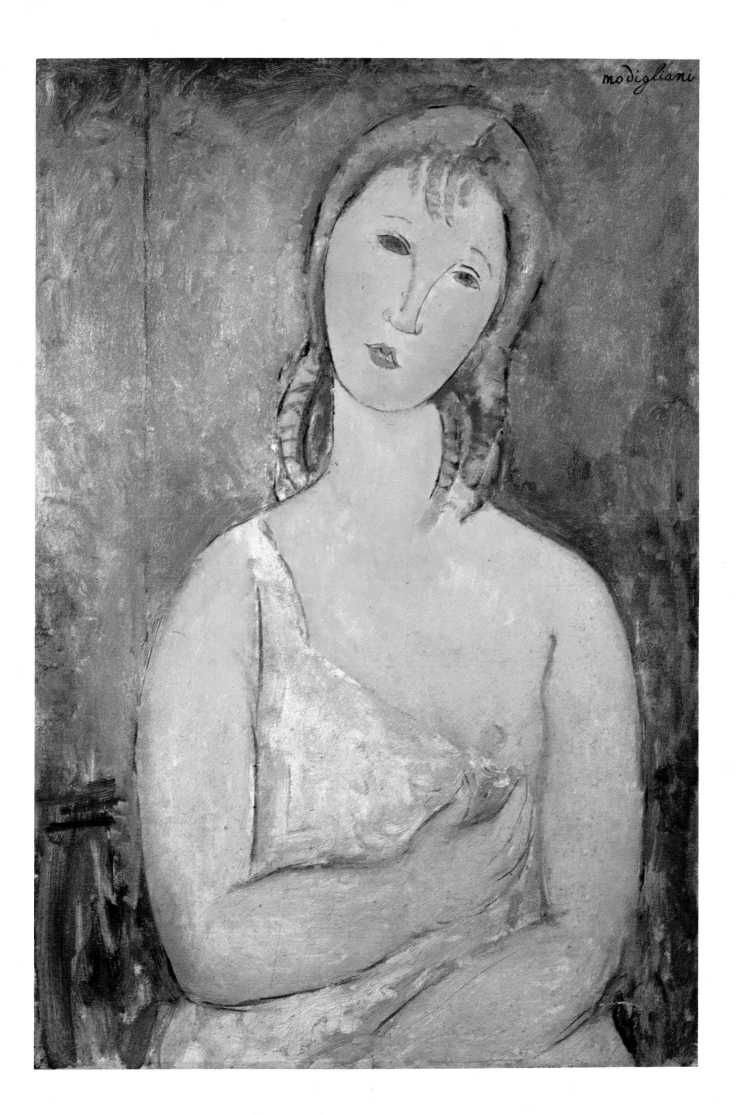

Jeanne Hébuterne

OIL ON CANVAS, 92 × 60 CM. 1918. PRIVATE COLLECTION

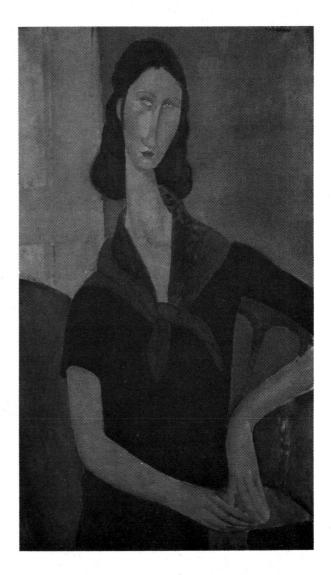

The sad story of Jeanne Hébuterne, the gifted young art student who devoted herself to Modigliani for the last three desperate years of his life and who committed suicide after his death, is an indissoluble part of the Modigliani legend. She bore him a daughter in November 1918 and became pregnant again the following summer, but this child was not born, dying with her on 25 January 1920.

The portraits of Jeanne Hébuterne are among the most beautiful of Modigliani's works but also among the most disturbing in human terms. Sometimes, as in Fig. 38, he portrays her as on equal terms with his other sitters, and at some distance from himself. More often, as in Plate 46, we sense the scrutiny that Modigliani might apply to someone who was very close to him and of whom he felt impatient, even resentful. This portrait was painted in the South of France during her first pregnancy, therefore in the summer or autumn of 1918, but it does not share the absolute simplicity of the best works of that time. Her complicated dress and striped sash disrupt the unity of the figure, and the pose is not clear. Certainly the face is painted with great care, not sparing the slight double chin. In a curious device with a finger of her right hand, Modigliani seems to be making her point to the child within her.

Fig. 38
Jeanne Hébuterne in an Armchair
OIL ON CANVAS, 92 × 54 CM. 1918. PRIVATE COLLECTION

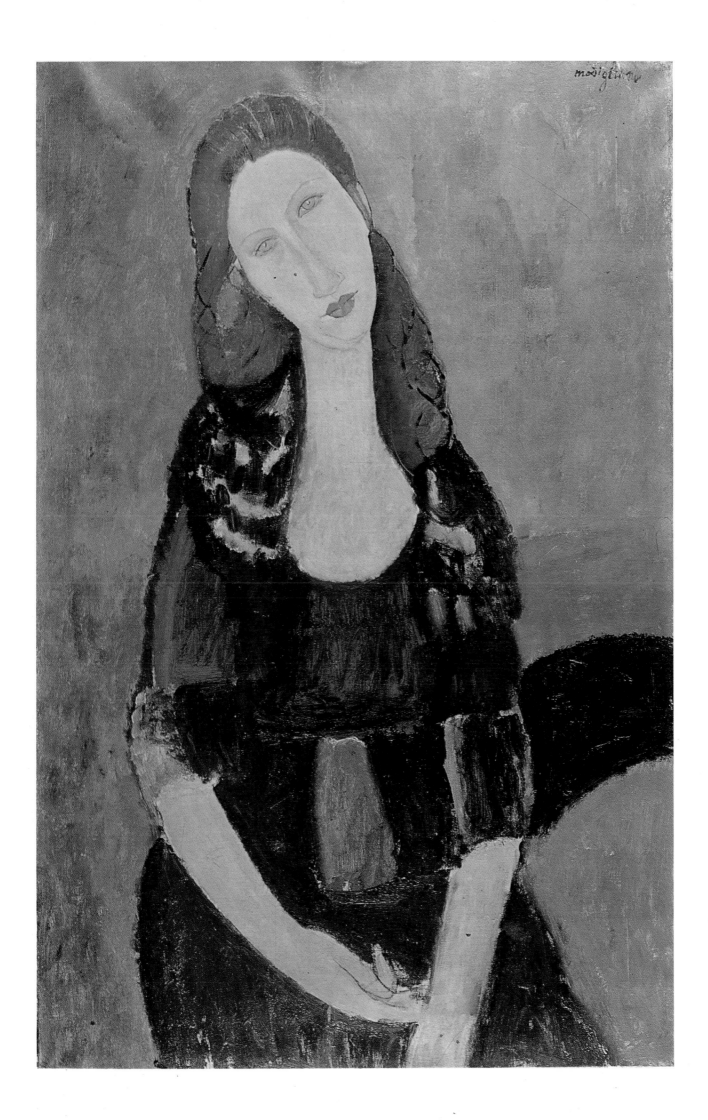

Jeanne Hébuterne in Profile

OIL ON CANVAS, 100 × 65 CM. 1918. PRIVATE COLLECTION

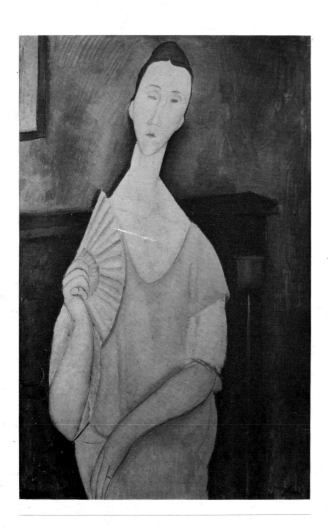

This version of Jeanne is one of Modigliani's most startling and original works. The profile pose enables him to endow his already celebrated long neck with its most serpentine form, and combined with Jeanne's Egyptian hair style it produces a high degree of formality. The composition of the whole canvas supports this culmination to great effect. The profile pose also allows the painter to use his subject's pregnancy more effectively, providing a tapering base, which rises gently from the knees to the shoulders. Everything else is subordinated to this grand design — the flat exquisitely painted background, the canvas against the wall buttressing the sitter from behind, the very restricted palette of colours appropriate to the South, with sleeves, skirt and chairback in the same dull red. It displays among all the paintings in this book the finest *taste* — a word that in this context can have no derogatory implications. A similar attention to fine taste, especially in the decorative drawing of the hand holding the fan, can be seen in the near-contemporary portrait of Modigliani's friend Lunia Czechowska (Fig. 39).

Yet Modigliani habitually left in his work some touch of gall and would hardly be himself without it. Here it may be found in the treatment of the face, which, while rendered with the same delicacy as the rest of the painting, is wincingly unflattering to the sitter. Portrayed here as in Plate 46 during her first pregnancy, Jeanne sits cowlike and absorbed in her own being, as if oblivious to her wild and dissolute painter companion.

Fig. 39
Woman with a Fan (Portrait of Lunia Czechowska)
OIL ON CANVAS, 100 × 65.1 CM. 1919. MUSÉE D'ART MODERNE DE VILLE DE PARIS

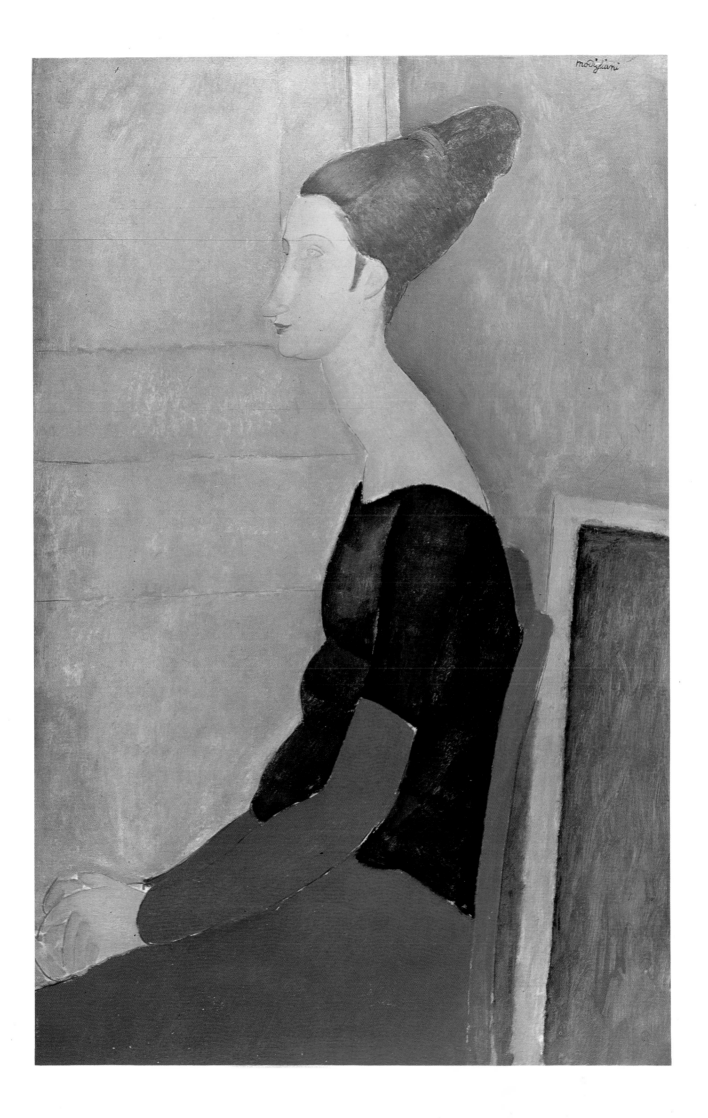

Jeanne Hébuterne, a Door in the Background

OIL ON CANVAS, 130 × 81 CM. 1919–20. PRIVATE COLLECTION

Back in Paris from the South, Jeanne is pregnant for a second time. To judge from her size, the painting must date from late in 1919, even perhaps from the first three weeks of 1920 before Modigliani's death on 24 January. We see the dingier colours of the Paris background, above all the acute mannerism of the figure, echoed in the sharp perspective of the door and the dizzying way it is placed at an angle just left of centre to frame the sitter's head and breast. Where Plate 47 is cool and elegant, Plate 48 is sumptuous in colour, complex in its surface drawing and composition in depth. The picture is a *tour de force,* a great painting and one of the culminations of Modigliani's unhappy life. But it is precisely the unhappiness, the unease, that seize the attention and assert the painting as a human document rather than the beautiful work it is. Perhaps this impression comes more than anything else from the face, from its extreme blankness, drained of personality as it is drained of colour, pallid, chalky and ill. Only the body is eloquent.

It is primarily the group of paintings of Jeanne, of which this is the finest, that foster the idea of a 'last style' of Modigliani. The cool classicism of the Nice and Cagnes paintings, not always found even in them, had come to an end. So had the production of subject pictures such as Plates 40 to 45. Modigliani, now a very sick man in all senses, painted what was near to him. He did not invent a new style, but gave a free rein to the expressionism that had always been latent in him.

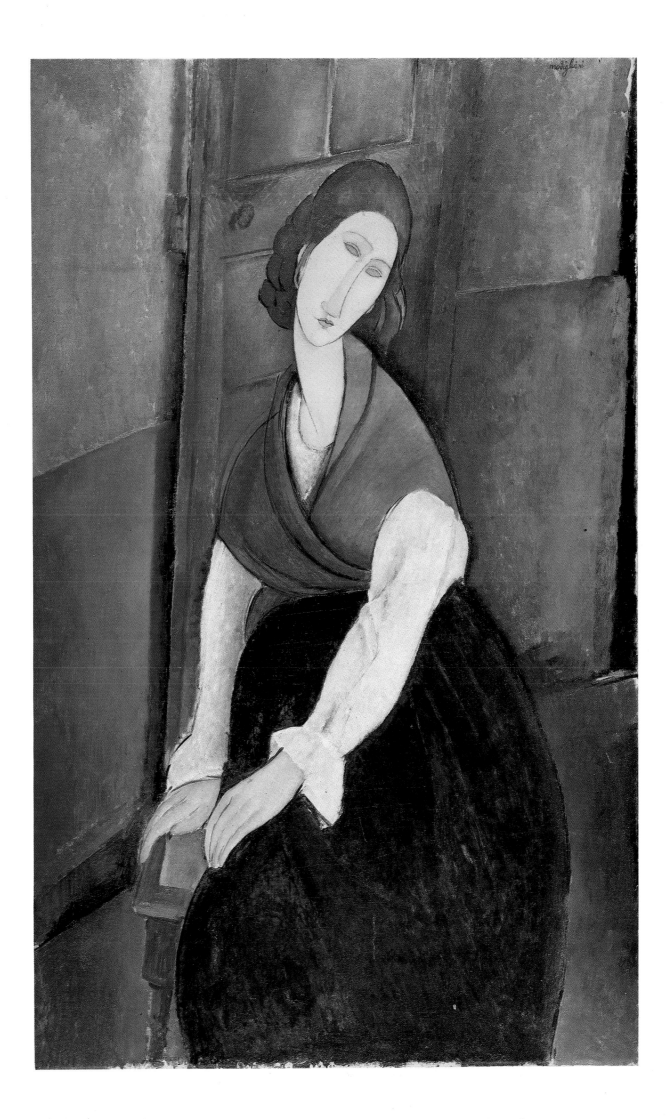